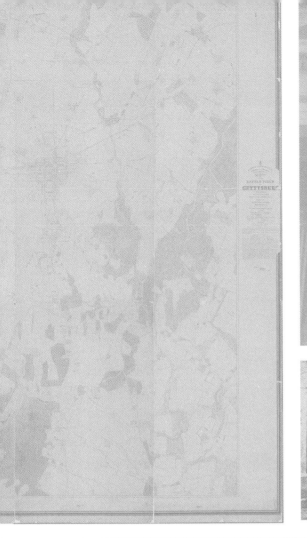

BIG!

Big Records, Big Events, and Big Ideas in American History

Celebrating 75 Years of the National Archives

by Stacey Bredhoff

With a message from
Allen Weinstein,
Ninth Archivist of the
United States

The Foundation for the National Archives,
Washington, DC,
in association with D Giles Limited, London

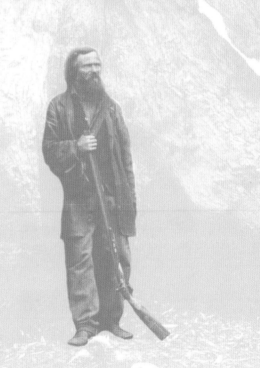
Galen Clark in front of "Grizzly Giant," a massive sequoia tree, Mariposa Grove, California, photograph by Carleton Watkins, not dated (digitally enhanced image)

National Archives, Records of the National Park Service (NPS) [79-BC-166]

MESSAGE FROM THE ARCHIVIST

The year 2009 is an especially "big" year for the National Archives—our 75th anniversary, in fact. At no other time in the agency's history has the National Archives served more researchers, maintained larger collections, or assumed a greater role in preserving and providing access to the records of the Federal Government.

To celebrate these accomplishments, we have collected some of the "largest" records from our holdings— large both in size and in historical significance. These items represent the breadth and diversity of the National Archives' immense collections, which include 9 billion records, millions of photographs, maps, and electronic records, and thousands of motion pictures and audio recordings.

The full-scale original records—some reproduced here with foldout pages—offer a detailed and nuanced view of American history in all its immediacy.

Consider the 19-page telegram sent by U.S. diplomat George Kennan from his post in Moscow in 1946. The 8,000-word message, known as the "Long Telegram," set a new direction for U.S. relations with the Soviet Union, establishing a policy of containment that held sway until the end of the Cold War half a century later.

The military personnel file of Gen. Douglas MacArthur is one of the biggest in the holdings of the National Archives–National Personnel Records Center in St. Louis, Missouri. From photographs to honors and awards, the many thousands of items in the file chronicle the famous five-star general's half-century of military service. Included is a Presidential directive indicating a memorable clash of power between military and civilian command.

Among the 13 million still pictures in the National Archives' collections are photographs of one of the most majestic National Parks in the land. Prints of mammoth glass-plate negatives by photographer Carleton Watkins capture the grandeur of the giant sequoias, the jagged granite peaks, and the spiraling waterfalls of Yosemite.

One of the largest artifacts included is kept in the National Archives' Center for Legislative Archives. It is a petition of some 150,000 signatures wound around two giant wooden spools on an apparatus that stands more than 5 feet tall. It was wheeled onto the Senate floor by advocates of the American bicycle industry who urged better roads for the burgeoning bicycling movement.

Big personalities and weighty national concepts and ideals are represented in the pages that follow. The original records tell the story of special accommodations for our nation's heaviest President, William Howard Taft, and of the designs considered for the monument to President Abraham Lincoln. The grand civic ideals of the nation are embodied in the National Archives' Dunlap Broadside, the first printed copy of the Declaration of Independence.

As the nation's record keeper and home of the Charters of Freedom—the Declaration of Independence, the Constitution of the United States, and the Bill of Rights—the National Archives has a big job to do. Our mission is to preserve these records and make them accessible so that our shared national heritage is available to all.

Allen Weinstein
Archivist of the United States

NATIONAL
ARCHIVES
1934–2009

INTRODUCTION
BIG!—Celebrating 75 Years of the National Archives

This book, featuring big records, big events, and big ideas, is based on an exhibition presented in 2009 in celebration of the 75th anniversary of the National Archives. With the computer age in full swing, as viewers struggle to see documents and records reproduced on screens growing ever smaller, the exhibit presented the original record shown in its full-scale glory.

Starting with the 13-foot scroll of the Articles of Confederation—the first constitution of the United States—the items here evoke the challenges, sacrifices, and even humor that are woven into the American tapestry. Among the items are an enormous map of the Gettysburg battlefield; a design proposed for the Lincoln Memorial; and the 1941 tally sheet of the votes in the House of Representatives (388 to 1) to declare war on Japan after the attack on Pearl Harbor. "BIG!" presents the order for the enormous bathtub custom made for America's biggest President; and the gigantic shoe owned by a powerhouse of an American athlete.

Finally, this presentation pays tribute to an idea so big it engendered the birth of this nation. Produced during the night of July 4–5, 1776, the first printing of the Declaration of Independence (opposite page) affirms an eternal truth about freedom in words that resound through the ages and throughout the world. It is one of the National Archives' greatest treasures.

On the 75th anniversary of this institution, the National Archives presents "BIG!"—pieces of the American story—writ large.

Stacey Bredhoff
Curator of "BIG!"

In CONGRESS, July 4, 1776.

A DECLARATION

By the REPRESENTATIVES of the

UNITED STATES OF AMERICA,

In GENERAL CONGRESS ASSEMBLED.

WHEN in the Course of human Events, it becomes necessary for one People to dissolve the Political Bands which have connected them with another, and to assume among the Powers of the Earth, the separate and equal Station to which the Laws of Nature and of Nature's God entitle them, a decent Respect to the Opinions of Mankind requires that they should declare the causes which impel them to the Separation.

We hold these Truths to be self-evident, that all Men are created equal, that they are endowed by their Creator with certain unalienable Rights, that among these are Life, Liberty, and the Pursuit of Happiness--That to secure these Rights, Governments are instituted among Men, deriving their just Powers from the Consent of the Governed, that whenever any Form of Government becomes destructive of these Ends, it is the Right of the People to alter or to abolish it, and to institute new Government, laying its Foundation on such Principles, and organizing its Powers in such Form, as to them shall seem most likely to effect their Safety and Happiness. Prudence, indeed, will dictate that Governments long established should not be changed for light and transient Causes; and accordingly all Experience hath shewn, that Mankind are more disposed to suffer, while Evils are sufferable, than to right themselves by abolishing the Forms to which they are accustomed. But when a long Train of Abuses and Usurpations, pursuing invariably the same Object, evinces a Design to reduce them under absolute Despotism, it is their Right, it is their Duty, to throw off such Government, and to provide new Guards for their future Security. Such has been the patient Sufferance of these Colonies; and such is now the Necessity which constrains them to alter their former Systems of Government. The History of the present King of Great-Britain is a History of repeated Injuries and Usurpations, all having in direct Object the Establishment of an absolute Tyranny over these States. To prove this, let Facts be submitted to a candid World.

He has refused his Assent to Laws, the most wholesome and necessary for the public Good.

He has forbidden his Governors to pass Laws of immediate and pressing Importance, unless suspended in their Operation till his Assent should be obtained; and when so suspended, he has utterly neglected to attend to them.

He has refused to pass other Laws for the Accommodation of large Districts of People, unless those People would relinquish the Right of Representation in the Legislature, a Right inestimable to them, and formidable to Tyrants only.

He has called together Legislative Bodies at Places unusual, uncomfortable, and distant from the Depository of their public Records, for the sole Purpose of fatiguing them into Compliance with his Measures.

He has dissolved Representative Houses repeatedly, for opposing with manly Firmness his Invasions on the Rights of the People.

He has refused for a long Time, after such Dissolutions, to cause others to be elected; whereby the Legislative Powers, incapable of Annihilation, have returned to the People at large for their exercise; the State remaining in the mean time exposed to all the Dangers of Invasion from without, and Convulsions within.

He has endeavoured to prevent the Population of these States; for that Purpose obstructing the Laws for Naturalization of Foreigners; refusing to pass others to encourage their Migrations hither, and raising the Conditions of new Appropriations of Lands.

He has obstructed the Administration of Justice, by refusing his Assent to Laws for establishing Judiciary Powers.

He has made Judges dependent on his Will alone, for the Tenure of their Offices, and the Amount and Payment of their Salaries.

He has erected a Multitude of new Offices, and sent hither Swarms of Officers to harrass our People, and eat out their Substance.

He has kept among us, in Times of Peace, Standing Armies, without the consent of our Legislatures.

He has affected to render the Military independent of and superior to the Civil Power.

He has combined with others to subject us to a Jurisdiction foreign to our Constitution, and unacknowledged by our Laws; giving his Assent to their Acts of pretended Legislation:

For quartering large Bodies of Armed Troops among us:

For protecting them, by a mock Trial, from Punishment for any Murders which they should commit on the Inhabitants of these States:

For cutting off our Trade with all Parts of the World:

For imposing Taxes on us without our Consent:

For depriving us, in many Cases, of the Benefits of Trial by Jury:

For transporting us beyond Seas to be tried for pretended Offences:

For abolishing the free System of English Laws in a neighbouring Province, establishing therein an arbitrary Government, and enlarging its Boundaries, so as to render it at once an Example and fit Instrument for introducing the same absolute Rule into these Colonies:

For taking away our Charters, abolishing our most valuable Laws, and altering fundamentally the Forms of our Governments:

For suspending our own Legislatures, and declaring themselves invested with Power to legislate for us in all Cases whatsoever.

He has abdicated Government here, by declaring us out of his Protection and waging War against us.

He has plundered our Seas, ravaged our Coasts, burnt our Towns, and destroyed the Lives of our People.

He is, at this Time, transporting large Armies of foreign Mercenaries to compleat the Works of Death, Desolation, and Tyranny, already begun with circumstances of Cruelty and Perfidy, scarcely paralleled in the most barbarous Ages, and totally unworthy the Head of a civilized Nation.

He has constrained our fellow Citizens taken Captive on the high Seas to bear Arms against their Country, to become the Executioners of their Friends and Brethren, or to fall themselves by their Hands.

He has excited domestic Insurrections amongst us, and has endeavoured to bring on the Inhabitants of our Frontiers, the merciless Indian Savages, whose known Rule of Warfare, is an undistinguished Destruction, of all Ages, Sexes and Conditions.

In every stage of these Oppressions we have Petitioned for Redress in the most humble Terms: Our repeated Petitions have been answered only by repeated Injury. A Prince, whose Character is thus marked by every act which may define a Tyrant, is unfit to be the Ruler of a free People.

Nor have we been wanting in Attentions to our British Brethren. We have warned them from Time to Time of Attempts by their Legislature to extend an unwarrantable Jurisdiction over us. We have reminded them of the Circumstances of our Emigration and Settlement here. We have appealed to their native Justice and Magnanimity, and we have conjured them by the Ties of our common Kindred to disavow these Usurpations, which, would inevitably interrupt our Connections and Correspondence. They too have been deaf to the Voice of Justice and of Consanguinity. We must, therefore, acquiesce in the Necessity, which denounces our Separation, and hold them, as we hold the rest of Mankind, Enemies in War, in Peace, Friends.

We, therefore, the Representatives of the UNITED STATES OF AMERICA, in GENERAL CONGRESS, Assembled, appealing to the Supreme Judge of the World for the Rectitude of our Intentions, do, in the Name, and by Authority of the good People of these Colonies, solemnly Publish and Declare, That these United Colonies are, and of Right ought to be, FREE AND INDEPENDENT STATES; that they are absolved from all Allegiance to the British Crown, and that all political Connection between them and the State of Great-Britain, is and ought to be totally dissolved; and that as FREE AND INDEPENDENT STATES, they have full Power to levy War, conclude Peace, contract Alliances, establish Commerce, and to do all other Acts and Things which INDEPENDENT STATES may of right do. And for the support of this Declaration, with a firm Reliance on the Protection of divine Providence, we mutually pledge to each other our Lives, our Fortunes, and our sacred Honor.

Signed by ORDER and in BEHALF of the CONGRESS,

JOHN HANCOCK, PRESIDENT.

ATTEST.
CHARLES THOMSON, SECRETARY.

PHILADELPHIA: PRINTED BY JOHN DUNLAP.

First printing of the Declaration of Independence, produced during the night of July 4–5, 1776

National Archives, Records of the Continental and Confederation Congresses and the Constitutional Convention

ARCHIVES OF THE UNI

D STATES OF AMERICA

Articles of Confederation

The First Constitution of the United States

Drafted in the heat of the battle for American independence, the Articles of Confederation served as the first formal, written constitution for the United States. During the eight years that the Articles of Confederation were in effect, the country concluded a successful War for Independence, negotiated a peace settlement, established a functioning bureaucracy, and provided for the expansion of a republican form of government into the western territories. Reluctant to create a strong government, the authors of the Articles denied Congress many important powers. Ultimately, the Articles proved unwieldy and inadequate to

resolve the issues that faced the United States in its earliest years; but in granting any Federal powers to a central authority—Congress—this document marked a crucial step toward nationhood.

The Articles of Confederation were adopted by Congress in November 1777 and ratified in March 1781. This official hand-written copy of the document—consisting of six sheets of parchment stitched together—was presented to Congress on July 9, 1778, and signed by all those present. Unrolled it extends 13 feet 5 inches.

Detail of the Articles of Confederation, adopted by Congress on November 15, 1777; ratified by the states on March 1, 1781

National Archives, Records of the Continental and Confederation Congresses and the Constitutional Convention

submitted to them. ably observed by every state, and the union shall be perpetual; nor shall any alteration at any time hereafter be made in any of them; unless such alteration be agreed to in a congress of the united states, and be afterwards confirmed by the legislatures of every state.

And Whereas it hath pleased the Great Governor of the World to incline the hearts of the legislatures we respectively represent in congress, to approve of, and to authorize us to ratify the said articles of confederation and perpetual union. **Know Ye** that we the under-signed delegates, by virtue of the power and authority to us given for that purpose, do by these presents, in the name and in behalf of our respective constituents, fully and entirely ratify and confirm each and every of the said articles of confederation and perpetual union, and all and singular the matters and things therein contained: And we do further solemnly plight and engage the faith of our respective constituents, that they shall abide by the determinations of the united states in congress assembled on all questions, which by the said confederation are submitted to them.

And that the articles thereof shall be inviolably observed by the states we respectively represent, and that the union shall be perpetual. **In Witness** whereof we have hereunto set our hands in Congress. **Done at Philadelphia** in the state of Pennsylvania the ninth Day of July in the Year of our Lord one Thousand seven Hundred and Seventy-eight, and in the third year of the independence of America.

Tho McKean

On the part & behalf of the State of Delaware

John Dickinson May 5th 1779

Nicholas Van Dyke

John Hanson Mar 1 1781

Daniel Carroll

Josiah Bartlett

John Wentworth Jun
august 8th 1778

On the part & behalf of the State of New Hampshire

John Hancock

Richard Henry Lee

John Banister

Thomas Adams

Jno Harvie

Francis Lightfoot Lee

Samuel Adams

George ...

Francis Dana

James ...

From the Articles

Article I. *The Stile of this Confederacy shall be "The United States of America."*

Article II. *Each state retains its sovereignty, freedom, and independence . . .*

Article III. *The said States hereby severally enter into a firm league of friendship with each other, for their common defense, the security of their liberties, and their mutual and general welfare . . .*

Article IV. *. . . the free inhabitants of each of these States . . . shall be entitled to all privileges and immunities of free citizens in the several States . . .*

Article V. *. . . In determining questions in the United States in Congress assembled, each State shall have one vote . . .*

Freedom of speech and debate in Congress shall not be impeached . . .

Article VI. *No State . . . shall send any embassy to, or receive any embassy from, or enter into any conference, agreement, alliance or treaty with any King, Prince or State . . .*

No two or more States shall enter into any treaty, confederation or alliance whatever between them . . .

No State shall lay any imposts or duties, which may interfere with any stipulations in treaties, entered into by the United States in Congress assembled . . .

No vessel of war shall be kept up in time of peace by any State, except such number only, as shall be deemed necessary by the United States in Congress assembled

No State shall engage in any war without the consent of the United States in Congress assembled . . .

Article VII. *When land forces are raised by any State for the common defense, all officers of or under the rank of colonel, shall be appointed by the legislature of each State respectively . . .*

Opposite and foldout: Detail of the Articles of Confederation, adopted by Congress on November 15, 1777; ratified by the states on March 1, 1781
National Archives, Records of the Continental and Confederation Congresses and the Constitutional Convention

Article VIII. All charges of war, and all other expenses that shall be incurred for the common defense or general welfare . . . shall be defrayed out of a common treasury . . .

Article IX. The United States in Congress assembled, shall have the sole and exclusive right and power of determining on peace and war . . .

. . . shall also be the last resort on appeal in all disputes and differences now subsisting or that hereafter may arise between two or more States concerning boundary, jurisdiction or any other causes whatever . . .

. . . shall also have the sole and exclusive right and power of regulating the alloy and value of coin struck . . . [of] regulating the trade and managing all affairs with the Indians, [of] establishing or regulating post offices . . . [of] appointing all officers of the land forces, in the service of the United States . . . [of] appointing all the officers of the naval forces . . .

The United States in Congress assembled shall have authority to appoint a committee . . . to ascertain the necessary sums of money to be raised for the service of the United States . . . to borrow money, or emit bills on the credit of the United States . . . to build and equip a navy . . . to agree upon the number of land forces, and to make requisitions from each State for its quota . . .

Article X. The Committee of the States . . . shall be authorized to execute . . . such of the powers of Congress as the United States in Congress assembled, by the consent of the nine States, shall from time to time think expedient to vest them with . . .

Article XI. Canada acceding to this confederation shall be admitted into, and entitled to all the advantages of this Union . . .

Article XII. All bills of credit emitted, monies borrowed, and debts contracted by, or under the authority of Congress, before the assembling of the United States . . . shall be deemed and considered as a charge against the United States . . .

Article XIII. And the Articles of this Confederation shall be inviolably observed by every State, and the Union shall be perpetual . . .

If any Person guilty of, or charged with treason, felony, or other high misdemeanor in any State, shall flee from Justice, and be found in any of the united States, he shall upon demand of the Governor or executive power, of the State from which he fled, be delivered up and removed to the State having jurisdiction of his offense. Full faith and credit shall be given in each of these States to the records, acts and judicial proceedings of the courts and magistrates of every other State.

Article V. For the more convenient management of the general interests of the united States, delegates shall be annually appointed in such manner as the legislature of each State shall direct, to meet in Congress on the first Monday in November, in every year, with a power reserved to each State, to recal its delegates, or any of them, at any time within the year, and to send others in their stead, for the remainder of the Year.

No State shall be represented in Congress by less than two, nor by more than seven Members; and no person shall be capable of being a delegate for more than three years in any term of six years; nor shall any

Each State shall maintain its own delegates in a meeting

GETTYSBURG

This map shows approximately 26 square miles of terrain in and around Gettysburg, Pennsylvania, site of one of the most crucial battles in the Civil War—and in U.S. history. It was used as a base for the creation of other maps that illustrate the troop movements on July 1–3, 1863.

The map, in its original format, comprises 20 sections and measures approximately 13 by 13 feet when fully assembled. The scale is 1 inch to 200 feet.

SUMMARY OF BATTLE

Two years into the Civil War, in June 1863, Confederate Gen. Robert E. Lee's Army of Northern Virginia—some 75,000 men—was on the offensive. Invading Pennsylvania, Lee sought a conclusive victory on Northern soil. Union Gen. George Meade's Army of the Potomac—some 95,000 men—was trying to track them, intent on remaining between Lee's army and the Union's capital city of Washington, DC. Neither side had selected Gettysburg as the site of a major engagement, but it was there that the two armies met by happenstance and became locked in a ferocious bloodbath that raged July 1–3. Many historians believe it turned the tide of the war toward a Union victory.

On June 30, Gen. John Buford and 2,700 Union cavalrymen arrived in Gettysburg in advance of Meade's army and soon learned that the vanguard of the enemy was just 7 miles northwest of the town. Buford recognized the terrain of gently sloping hills as having good defensive ground and secured a position that allowed him to watch for the approach of the enemy. Buford sent word back to the nearest infantry commander, Gen. John Reynolds, and early the next morning, the Union infantry of his command marched toward Gettysburg. Meanwhile Confederate infantry was also moving toward Gettysburg and the opening clash occurred that morning west of town. After a daylong battle, Lee's Southerners succeeded in driving the Union forces into Gettysburg. The Union troops rallied on high ground south of Gettysburg and reinforced this commanding position as more troops arrived on both sides. For the next two days, the Union held the high ground against massive assaults by Lee's army, including the legendary "Pickett's Charge" of July 3, one of the great infantry charges in military history.

At close of day on July 3, approximately 7,000 dead lay upon the blood-soaked fields. Total casualties—including killed, wounded, captured, and missing—exceeded 50,000. To this day, the Battle of Gettysburg remains the deadliest ever fought in North America. Although the war continued for almost two more years, never again could Lee mount a large-scale invasion of the North.

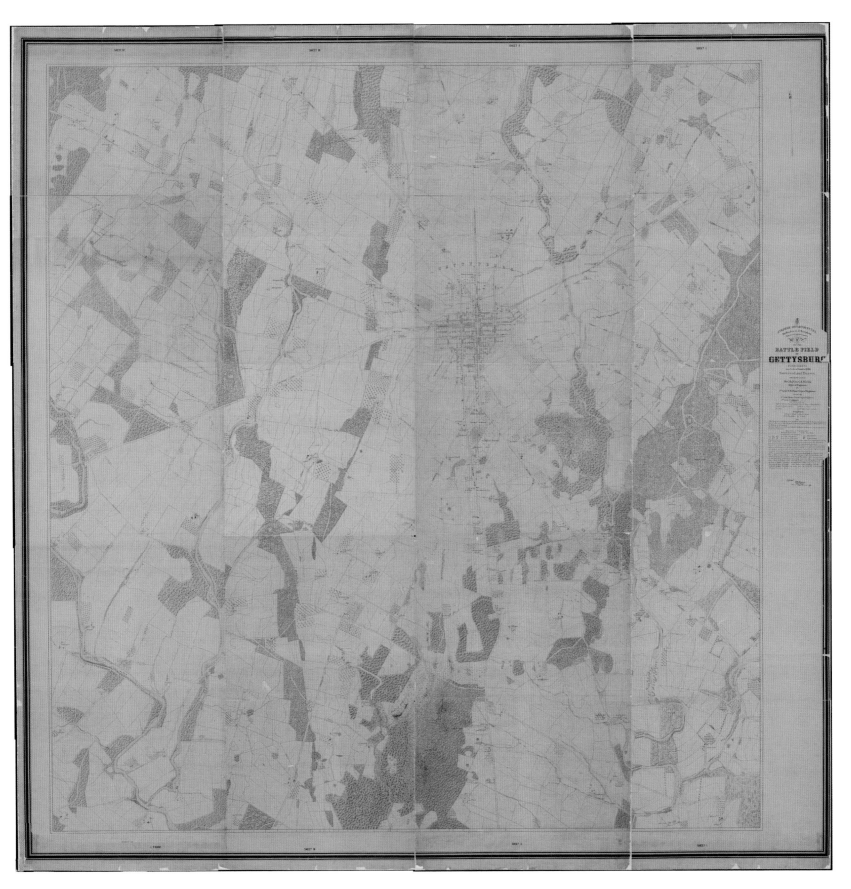

"Map of the Battle Field of Gettysburg," surveyed and drawn under the direction of Bvt. Maj. Gen. Gouverneur K. Warren, major of engineers, 1868–69, revised 1873. During the battle, Warren served as topographical engineer for Union Gen. George G. Meade, commander of the Army of the Potomac.

National Archives, Records of the Office of the Chief of Engineers

Pickett's Charge

By 11 A.M. on July 3, the two armies were aligned along two ridges, roughly parallel to each other, with a mile of open farmland between them. The Union forces were concentrated along Cemetery Ridge, shown in this map (opposite page) to be the high ground. The Confederates occupied a line along Seminary Ridge, south and west of the town. Lee's strategy for the third day of fighting, against the counsel of one of his commanders—Gen. James Longstreet—was a frontal assault on the center of the Union line.

At 3 P.M., a mile-long line of 12,000 Confederate soldiers emerged from fields in front of and trees behind Seminary Ridge and began their assault in parade formation across the field. Almost immediately, Union artillery fire rained down on them. Union troops watched from their entrenched position as the human wave advanced towards them at a quick walk—straight through the storm of exploding shells, solid shot, and, finally, small arms fire. As men dropped, others closed ranks and kept moving. It was a demonstration of resolve and courage that survivors on both sides would remember for the rest of their lives.

This assault, known as Pickett's Charge, was actually led by three commanders: Gen. George Pickett, Gen. J. J. Pettigrew, and Gen. Isaac Trimble.

12

"We shattered their lines with our fire, and every time they just closed up and closed up again as if nothing had happened and kept right on."
Union veteran recalling Pickett's Charge 50 years later, as reported in the *New York Times*, July 4, 1913

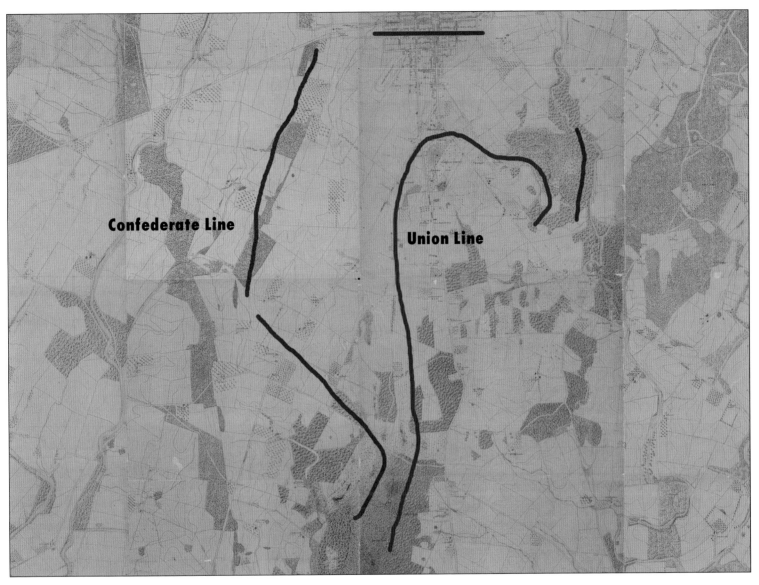

The detail of the map shown here has been annotated to illustrate the main Union and Confederate positions on July 3, prior to Pickett's Charge.

"Foot to foot, body to body, and man to man they struggled, pushed, and strived and killed. Each had rather die than yield. The mass of wounded and heaps of dead entangled the feet of the contestants . . .

[the men] hatless, coatless, drowned in sweat, black with powder, red with blood, stifling in the horrid heat, parched with smoke and blind with dust, with fiendish yells and strange oaths they blindly plied their work of slaughter."

Ernest Waitt, member of the 19th Massachusetts, recalling how Union troops fought to hold their position during Pickett's Charge

Town of Gettysburg

At the time of the Civil War, Gettysburg, population 2,400, was a bustling hub of local enterprise in southern Pennsylvania, populated by farmers, merchants, craftsmen, laborers, housemaids, cooks, washerwomen, doctors, lawyers, and teachers. The seat of Adams County, Gettysburg, was at the intersection of 10 roads. Farmland, fields, orchards, and woodlots surrounded Gettysburg, which had some 400 to 450 buildings. During the battle, many of those buildings—churches, barns, homes—became hospitals for the wounded, who were tended by the women of the town. Residents of the houses situated between the battle lines generally fled or received orders to vacate their homes.

Bryan (Brian) farm: Abraham and Elizabeth Brian had taken their two sons and fled their 12-acre farm (marked on the map just east of Emmitsburg Road) because, like other African Americans living in this area, they feared capture by Confederate soldiers.

"High Water Mark": Gen. Lewis Armistead, one of Pickett's brigadiers, followed by an estimated 200 officers and men, briefly penetrated the Union line on Cemetery Ridge. He was shot and died two days later. Those who accompanied him were shot down, captured, or made good their escape to Seminary Ridge. By 4 P.M., the battle was over, and early on July 4, Lee's army began its retreat to Virginia. The small grove of trees inside the area where Armistead's men had breached the stone fence atop Cemetery Ridge was later designated by a historian of the battle as the "High Water Mark of the Rebellion."

House where Jennie Wade died: On July 3, the final day of the battle, many of the town's residents had sought the relative safety of their cellars. But not 20-year-old Jennie Wade, who was visiting a house on Baltimore Street just a few blocks south of the town's center while helping to care for her sister's newborn baby; Wade was baking bread for Union soldiers at 8:30 A.M. when a bullet entered the house and lodged in her back. Hers was the only civilian death of the battle.

Site where Lincoln delivered Gettysburg Address

In November 1863, four months after the battle, President Abraham Lincoln came to Gettysburg to dedicate the national cemetery for the Union dead. In his remarks, he paid tribute to the brave men who died there and found, in their sacrifice, the will to fulfill America's promise. Lincoln's Gettysburg Address, a rhetorical masterpiece delivered in less than three minutes, defined the war as necessary for the survival of the nation and its ideals.

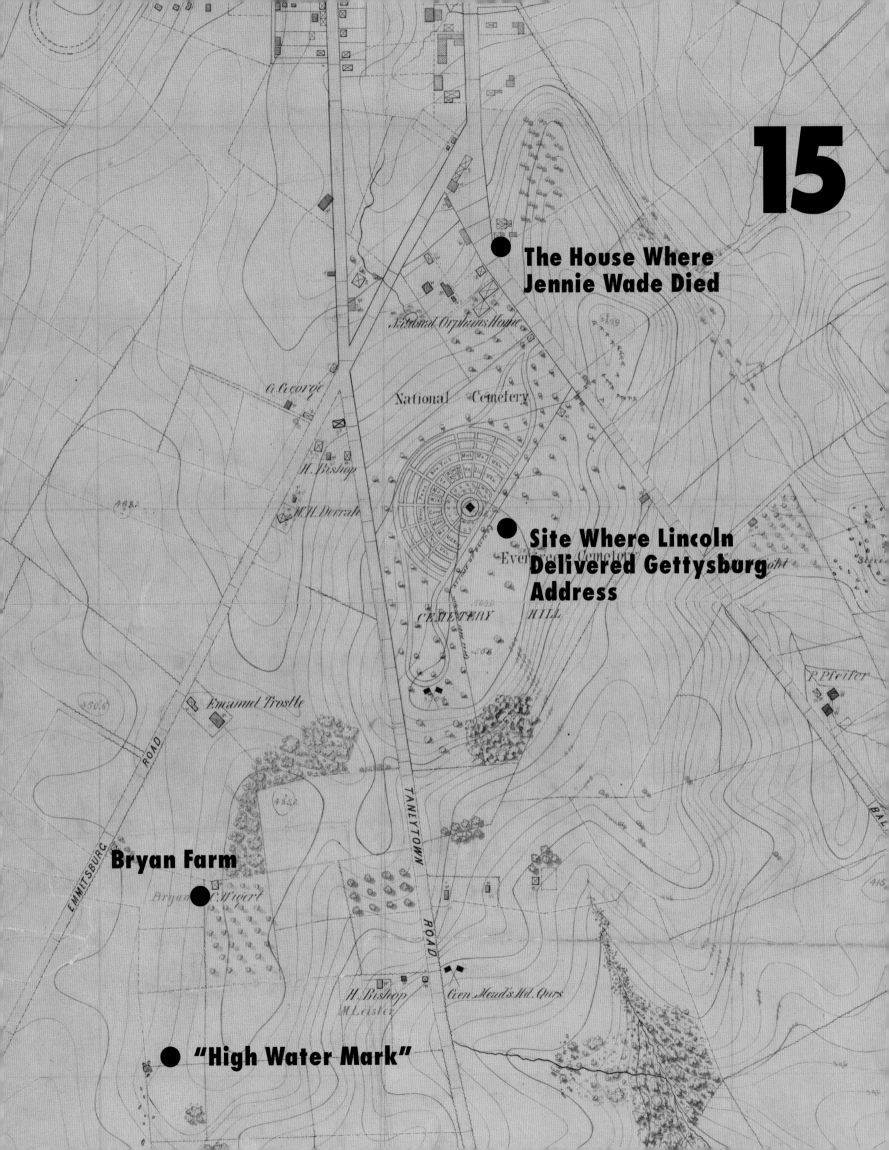

15

The House Where
Jennie Wade Died

Site Where Lincoln
Delivered Gettysburg
Address

Bryan Farm

"High Water Mark"

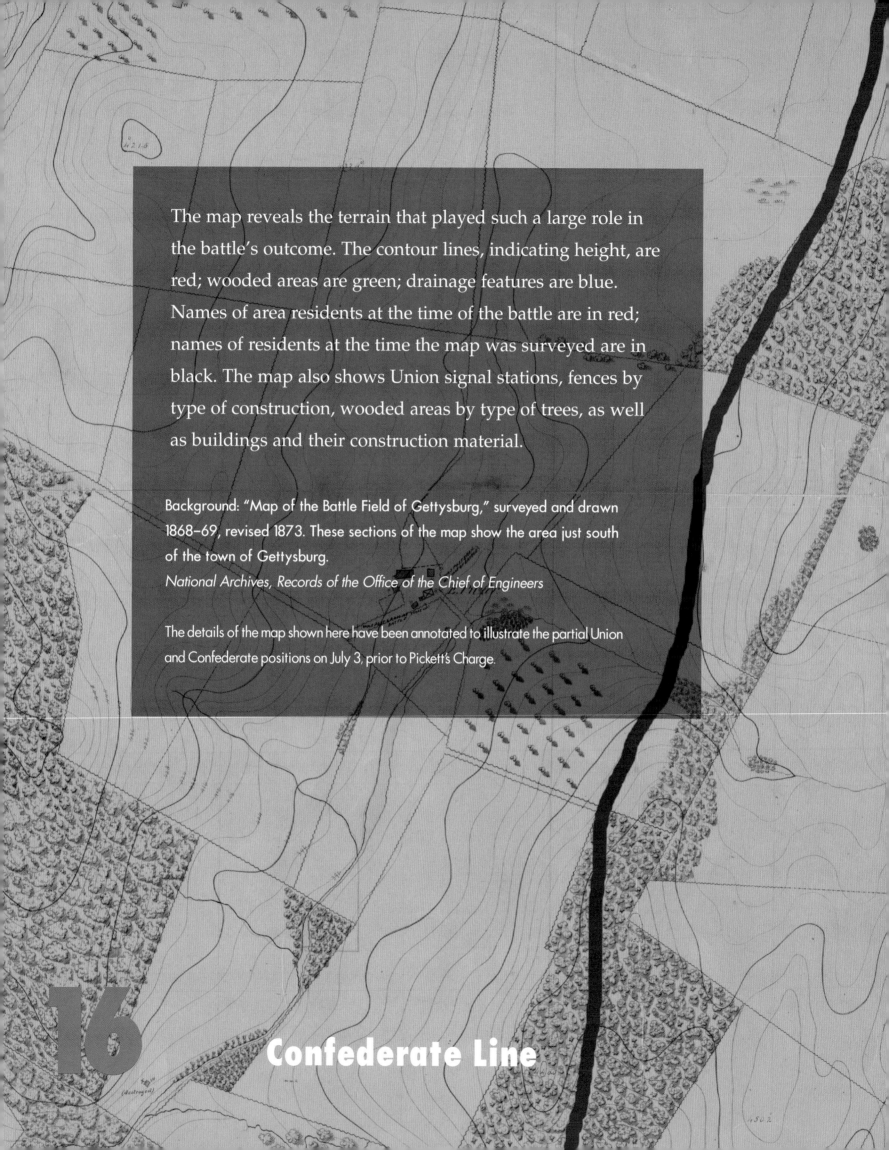

The map reveals the terrain that played such a large role in the battle's outcome. The contour lines, indicating height, are red; wooded areas are green; drainage features are blue. Names of area residents at the time of the battle are in red; names of residents at the time the map was surveyed are in black. The map also shows Union signal stations, fences by type of construction, wooded areas by type of trees, as well as buildings and their construction material.

Background: "Map of the Battle Field of Gettysburg," surveyed and drawn 1868–69, revised 1873. These sections of the map show the area just south of the town of Gettysburg.
National Archives, Records of the Office of the Chief of Engineers

The details of the map shown here have been annotated to illustrate the partial Union and Confederate positions on July 3, prior to Pickett's Charge.

16

Confederate Line

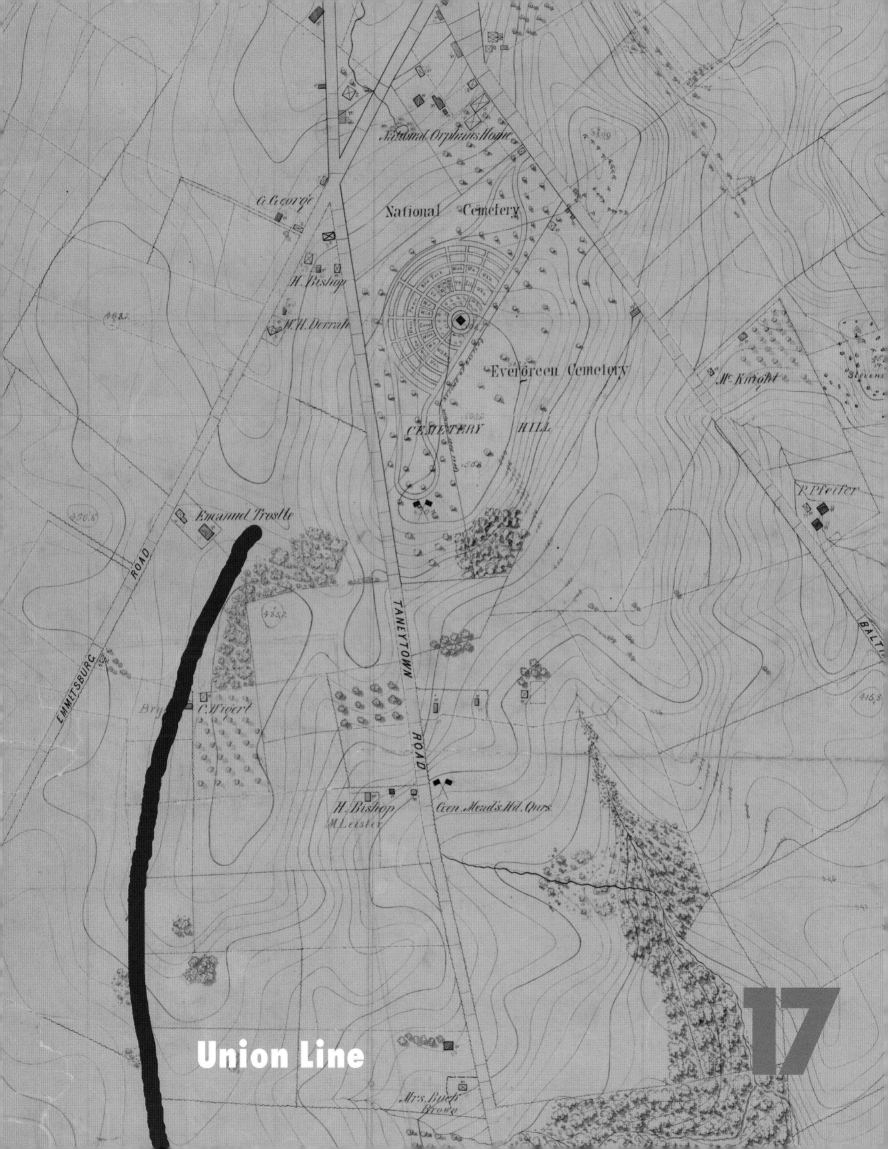

National Orphans Home

G. George

National Cemetery

H. Bishop

W.H. Derrah

Evergreen Cemetery

Mc Knight

Stevens

CEMETERY HILL

R. Pfeifer

Emanuel Trostle

TANEYTOWN ROAD

ROAD

EMMITSBURG

Bry

C. Wiert

H. Bishop
M. Leister

Gen. Mead's Hd. Qrs.

BALT

Mrs. Bush
Brown

Union Line

17

The Gettysburg Address

Four score and seven years ago our fathers brought forth upon this continent, a new nation, conceived in liberty, and dedicated to the proposition that all men are created equal.

Now we are engaged in a great civil war, testing whether that nation, or any nation so conceived and so dedicated, can long endure. We are met on a great battlefield of that war. We have come to dedicate a portion of that field, as a final resting place for those who here gave their lives that that nation might live. It is altogether fitting and proper that we should do this.

But, in a larger sense, we can not dedicate—we can not consecrate—we can not hallow—this ground. The brave men, living and dead, who struggled here have consecrated it, far above our poor power to add or detract. The world will little note, nor long remember what we say here, but it can never forget what they did here. It is for us the living, rather, to be dedicated here to the unfinished work which they who fought here have thus far so nobly advanced. It is rather for us to be here dedicated to the great task remaining before us—that from these honored dead we take increased devotion to that cause for which they gave the last full measure of devotion—that we here highly resolve that these dead shall not have died in vain—that this nation, under God, shall have a new birth of freedom—and that government of the people, by the people, for the people, shall not perish from the earth.

Abraham Lincoln, November 19, 1863

18

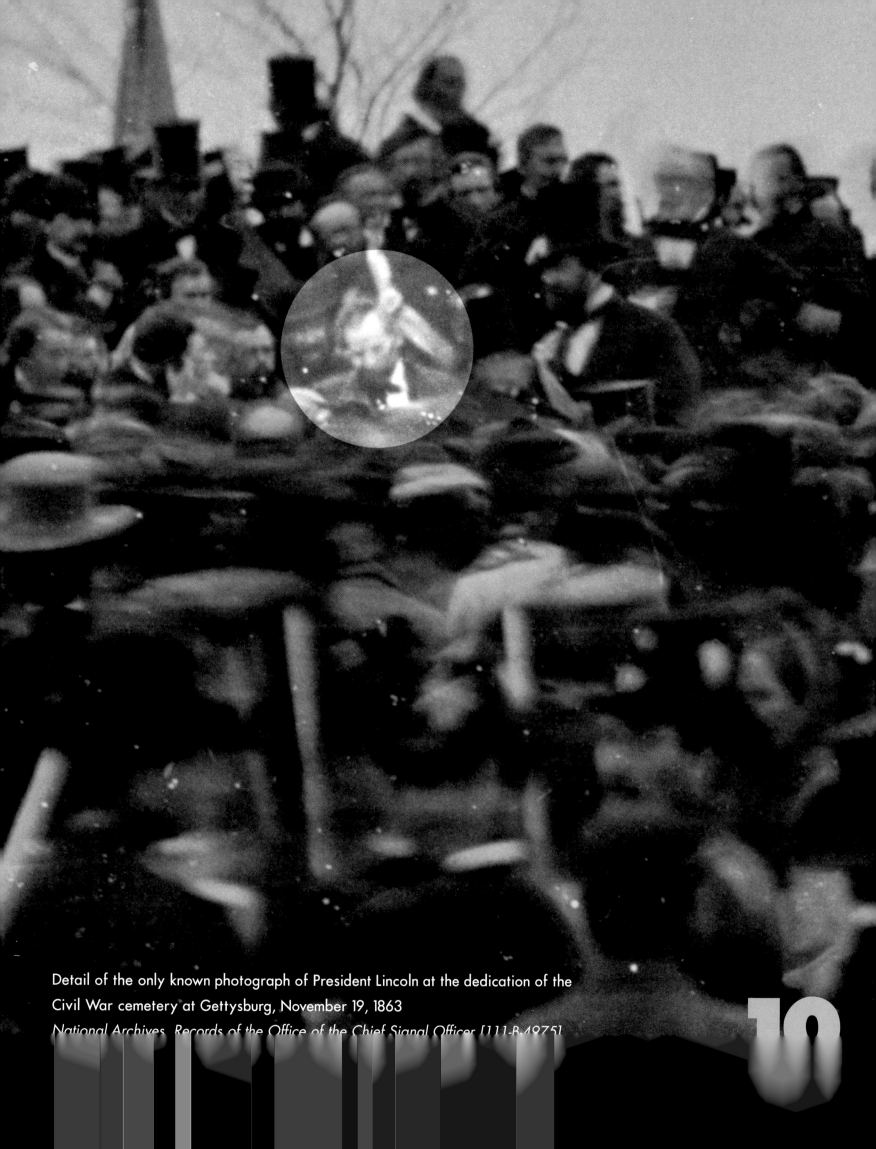

Detail of the only known photograph of President Lincoln at the dedication of the Civil War cemetery at Gettysburg, November 19, 1863

National Archives, Records of the Office of the Chief Signal Officer [111-B-4975]

10

Lincoln Memorial— An Alternative Design

Nearly half a century after Lincoln dedicated the national cemetery at Gettysburg, Congress appropriated money to plan a monument dedicated to his memory. Two of the nation's leading architects, Henry Bacon and John Russell Pope, were asked to submit competing designs for a site near the Potomac River. This drawing was submitted by Pope, architect of several Washington, DC, landmarks, including the National Archives Building.

The design ultimately chosen for the memorial was created by New York architect Henry Bacon. Dedicated in 1922, the Lincoln Memorial features a rectangular structure of monumental proportions modeled on a Greek temple, with two of Lincoln's great speeches inscribed on the walls. The emotional focal point of the memorial is the colossal seated figure of Lincoln, enshrined in repose, where he rests—majestic, serene, and eternal.

Foldout: John Russell Pope's competition proposal for a monument to Abraham Lincoln, located at the western end of the Mall, 1912; pencil, watercolor, and gouache rendering by Otto R. Eggers

National Archives, Records of the Office of Public Buildings and Public Parks of the National Capital

20

Facts about the Lincoln Memorial

A major feature of the memorial's design is its huge scale:

- The site of the Lincoln Memorial is longer than three football fields.

- The memorial is surrounded by 36 columns, each 44 feet high and 23 feet around the base.

- The seated figure of President Lincoln is 19 feet high; if the figure were to stand, it would be 28 feet high.

23

American Prisoners of War
SOUTHEAST ASIA

"The most basic principle of personal honor in America's armed forces is never willingly to leave a fellow serviceman behind . . ."

Report of the Senate Select Committee on POW/MIA Affairs, January 13, 1993

In 1973, at the end of the Vietnam War, 591 American POWs were released and returned to the United States. Many had endured years of brutal mistreatment, which they resisted with courage and honor. Operation Homecoming marked the end of the longest wartime captivity of American prisoners in U.S. history. But approximately 100 American servicemen, who had been expected to return, did not. Questions regarding their fates continued to torment their families and the nation: Was it possible that American servicemen had been left behind? Could some of them still be alive, held somewhere in Southeast Asia as prisoners? In 1991–92, Congress held hearings to investigate these questions.

The investigation focused on "live-sighting" reports, the firsthand or hearsay reports that Americans had been seen alive after 1973 "in circumstances not readily explained." Each of the 928 flag pins on this map represents a live-sighting report. Investigators studied all such sightings, sorted them by location, and plotted them on this large map of Southeast Asia. Known as the "cluster analysis map," this tool was devised by the Defense Intelligence Agency (DIA) to determine if live sightings would cluster at certain locations.

After more than a year of investigation, the committee found no compelling evidence that American POWs remain alive in Southeast Asia. Today, nearly 1,800 Americans remain unaccounted for.

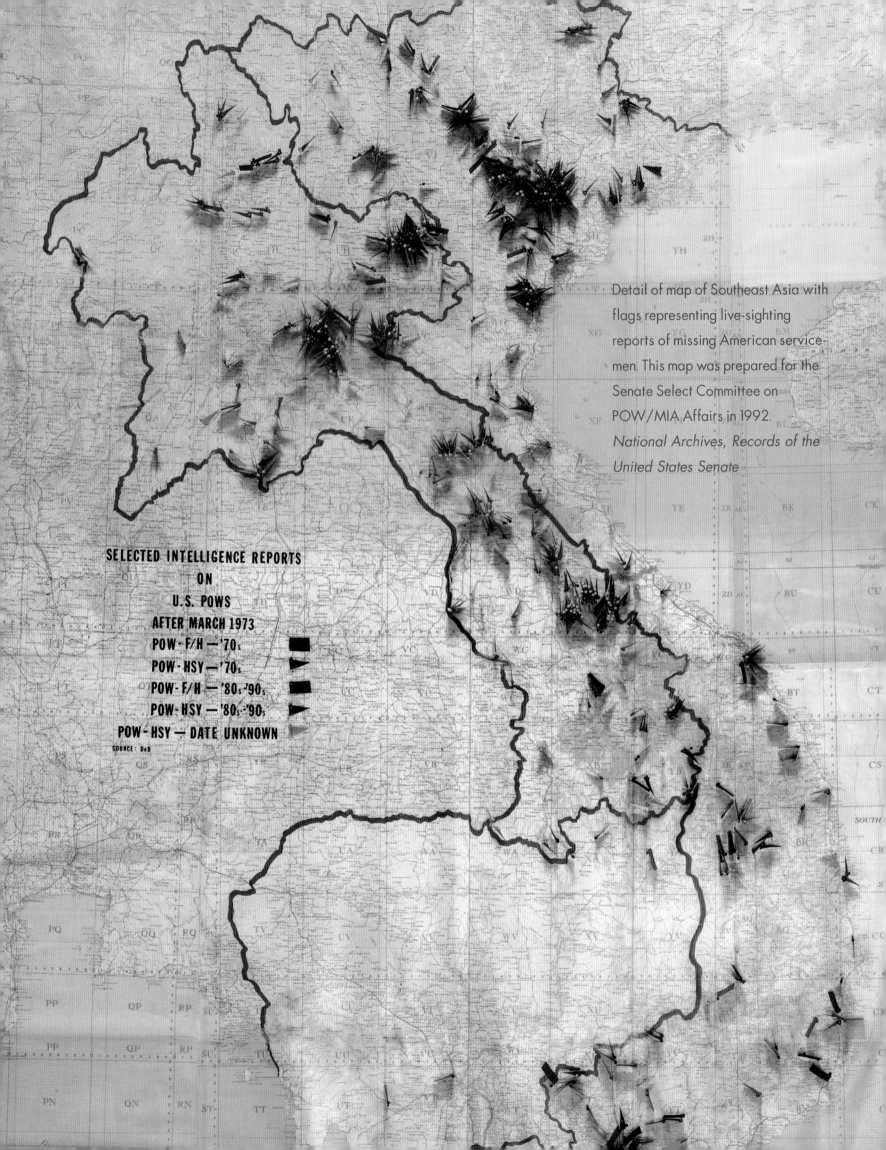

Detail of map of Southeast Asia with flags representing live-sighting reports of missing American servicemen. This map was prepared for the Senate Select Committee on POW/MIA Affairs in 1992. *National Archives, Records of the United States Senate*

SELECTED INTELLIGENCE REPORTS
ON
U.S. POWS
AFTER MARCH 1973
POW - F/H — '70s
POW - HSY — '70s
POW - F/H — '80s-'90s
POW - HSY — '80s-'90s
POW - HSY — DATE UNKNOWN
SOURCE: DoD

Japanese Attack on
PEARL HARBOR

"This was very big and it was very noticeable and it was just something out of the ordinary."

U.S. Army technician describing the radar signals of the Japanese planes approaching their targets at Pearl Harbor, Oahu, Hawaii, on December 7, 1941

At 4 A.M. on December 7, 1941, two young privates began their shift at a new mobile radar station near the northern tip of Oahu, Hawaii. Their job was to detect any incoming planes and report their findings to the Information Center some 50 miles away. Pvt. Joseph Lockard, the more experienced of the two, operated the "scope" and called out the information to Pvt. George Elliott, who plotted the signals on a sheet of paper. Their quiet shift ended at 7 A.M., but they lingered over the equipment to get some extra practice with the new technology. At 7:02 A.M., a huge white blip appeared on the screen.

Lockard called the Information Center and spoke with the only officer on duty, Lt. Kermit Tyler, an air force pilot. It was his second day on the job, and he knew nothing about radar technology. He was aware that a group of B-17s were due in from San Francisco, and he told Lockard not to worry about what he saw.

It was only when Lockard and Elliott returned to their camp about 30 minutes later, saw the men staring up at the black, billowing smoke in the sky, and learned of the Japanese

Right: Radar plot recording incoming Japanese aircraft approaching their targets, Oahu, Hawaii, December 7, 1941
National Archives, Records of the United States Senate

CLARA

7:02 AM

7:05

7:08

DINAH

7:11

7:13

34

35

7:15

7:16

7:18

7:20

7:23

646

7:25 AM

7:27

7:28

7:30

7:31

7:35

7:37

7:39

7:40 AM

attack on Pearl Harbor that they realized they had detected the first wave of Japanese planes approaching their American targets.

This is the original radar plot, marked by Pvt. George Elliott on the morning of December 7. It was entered into evidence during the 1946 Congressional Investigation of the Pearl Harbor Attack.

In February 1942 Lockard was awarded the Distinguished Service Medal for "exceptionally meritorious service" in detecting and reporting the large number of incoming planes on the morning of December 7, 1941; Elliott received a letter of commendation.

In August 1942 the officer on duty at the Information Center, Lt. Kermit Tyler, was cleared of any wrongdoing by a Navy Court of Inquiry, which found that he had received no training, no supervision, and no staff with which to accomplish his work.

PLOT OF STATION OPANA

ISLAND OF

OAHU

0 5 10 15 30 45 60

SCALE IN STATUTE MILES

QN V.1.2

OPANA

7 Dec 41

The Japanese attack on the U.S. naval base on Oahu began at 7:53 A.M.; the second wave came at 8:55 A.M. In less than 2 hours, the United States suffered 3,435 casualties, 188 planes, 8 battleships, 3 light cruisers, and 4 other vessels lost or severely damaged. The Japanese lost fewer than 100 personnel, 29 planes, and 5 midget submarines.

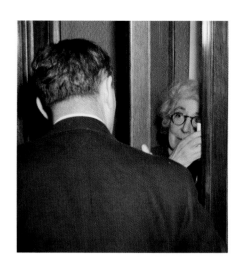

President Franklin D. Roosevelt was informed of the attack just after 1:30 P.M., Eastern time, or just after 8 A.M., Hawaii time, while the attack was still in progress. Within an hour, he realized that the Navy's Pacific fleet had been devastated. The following day, at 12:30 P.M., Eastern time, he addressed a Joint Session of Congress, pronounced December 7 "a day of infamy," and asked Congress for a formal declaration of war against Japan. Congress, in almost perfect unanimity, promptly complied. At 4:10 P.M., 28 hours after the first wave of Japanese planes appeared as a giant blip on the screen at the radar station in Hawaii, President Roosevelt signed the formal declaration of war against Japan; the United States entered World War II.

This tally sheet (opposite page) records the votes in the House of Representatives on the resolution for a declaration of war against Japan; it was adopted 388–1. Jeannette Rankin, representative from Montana and dedicated pacifist (she had voted against the resolution for entering World War I in 1917), was the only member of Congress to vote "no."

Right: Tally sheet recording the votes of the House of Representatives on the resolution to declare war against Japan, December 8, 1941.
National Archives, Records of the United States House of Representatives

Above: "After the roll call Representative Jeannette Rankin of Montana waited in a telephone booth until the House corridors were cleared. Talking to her is Representative Joseph W. Martin, Jr.," photograph by Associated Press Wirephoto, December 8, 1941.
Emotions ran high in the House Chamber that day, as members urged unanimity. Rankin tried repeatedly to raise her voice in protest during the debate; Speaker of the House Sam Rayburn ignored her. Undaunted, she attempted again to speak during the roll call vote; he pronounced her out of order. When she voted "no," she was answered by boos and hisses from the gallery. Afterwards, she sought refuge in a telephone booth.
Courtesy of AP Images, New York, New York

TALLY SHEET

Date _____

NAMES	NAY	YEA	NAMES	NAY	YEA	NAMES	NAY	YEA	NAMES	NAY	YEA	NAMES	NAY	YEA	NAMES	NAY
A			Collins		67	**A**			Kennedy, Martin J.			Osmers			Smith of Pennsylvania	
Allen of Illinois		67	Colmer		68	Gibson			Kennedy, Michael J.			O'Toole			Smith of Virginia	
Allen of Louisiana			Gifford						Keogh			**P**			Smith of Washington	
Andersen of Minnesota		69	Cooley			Gillette			Kerr			Pace			Smith of West Virginia	
Anderson of California		70	Cooper			Gilchrist			Kilburn			Paddock			Smith of Wisconsin	
Anderson of N. Mexico		71	Copeland			Gillie			Kilday			Patman			Snyder	
Andresen of Minnesota			Costello			Gore			Kinzer			Patrick			Somers of New York	
Andrews			Courtney			Gossett			Kirwan			Patton			South	
Angell			Cox			Graham			Kleberg			Pearson			Sparkman	
Arends			Cravens			Granger			Klein			Peterson of Florida			Spence	
Arnold			Crawford			Grant of Alabama			Knutson			Peterson of Georgia			Springer	
B			Creal			Grant of Indiana			Kocialkowski			Pfeifer, Joseph L.			Starnes of Alabama	
Baldwin			Crosser			Green			Kopplemann			Pheiffer, William T.			Stengall	
Barden of North Carolina			Crowther			Gregory			Kramer			Pierce			Stearns of New Hampshire	
Barnes			Culkin			Guyer of Kansas			Kunkel			Pittenger			Stefan	
Barry			Cullen			Gwynne			**L**			Plauché			Stevenson	
Bates of Kentucky			Cunningham			**H**			Lambertson			Ploeser			Stratton	
Bates of Massachusetts			Curtis			Haines			Landis			Plumley			Sullivan	
Baumhart			**D**			Hall, Edwin A.			Lanham			Poage			Sumner of Illinois	
Beam			D'Alesandro			Hall, Leonard W.			Larrabee			Powers			Sumners of Texas	
Beckworth						Halleck			Lea			Priest			Sutphin	
Beiter			Davis of Ohio			Hancock			Leavy						Sweeney	
Bell			Davis of Tennessee			Hare			LeCompte			**R**			**T**	
Bender			Day of Illinois			Harness			Lesinski			Rabaut			Taber	
Bennett			Delaney			Harrington			Lewis			Ramsay			Talle	
Bishop			Dewey			Harris of Arkansas			Ludlow			Ramspeck			Tarver	
Blackney			Dickstein			Harris of Virginia			Lynch			Randolph				
Bland			Dies			Hart of New Jersey			**M**			Rankin of Mississippi			Tenerowicz	
Bloom			Dingell			Harter of Ohio			McArdle			Rankin of Montana		1	Terry	
Boehne			Dirksen			Hartley of New Jersey			McCormack			Reece of Tennessee			Thill	
Boggs			Disney			Healey			McGehee			Reed of Illinois			Thom	
Boland			Ditter			Hébert			McGranery			Reed of New York			Thomas of New Jersey	
Bolton			Domengeaux			Heffernan			McGregor			Rees of Kansas			Thomas of Texas	
Bonner			Dondero			Heidinger			McIntyre			Rich			Thomason of Texas	
Boren			Doughton			Hendricks			McKeough			Richards			Tibbott	
Boykin			Douglas			Hess			McLaughlin			Rivers			Tinkham	
Bradley of Michigan			Downs			Hill of Colorado			McLean			Rizley			Tolan	
Bradley of Pennsylvania						Hill of Washington			McMillan			Robertson, North Dakota			Traynor	
Brooks			Drewry			Hinshaw			Maas			Robertson of Virginia			Treadway	
Brown of Georgia			Duncan			Hobbs			Maciejewski			Robinson of Utah			**V**	
Brown of Ohio			Durham			Hoffman			Maciora			Robsion of Kentucky			Van Zandt	
Bryson			Dworshak			Holbrock			Magnuson			Rockefeller			Vincent of Kentucky	
Buck			**E**			Holmes			Mahon			Rodgers of Pennsylvania			Vinson of Georgia	
Buckler of Minnesota			Eaton			Hook			Manasco			Rogers of Massachusetts			Voorhis of California	
Buckley of New York			Eberharter			Hope			Mansfield			Rogers of Oklahoma			Vorys of Ohio	
Bulwinkle			Edmiston			Houston			Marcantonio			Rolph			Vreeland	
Burch			Eliot of Massachusetts			Howell			Martin of Iowa			Romjue			**W**	
Burdick			Elliott of California			Hull			Martin of Massachusetts			Russell			Wadsworth	
Burgin			Ellis			Hunter			Mason						Walter	
Butler			Elston			**I**			May						Ward	
Byrne			Engel			Imhoff			Merritt						Wasielewski	
Byron			Englebright			Izac			Meyer of Maryland			**S**			Weaver	
C			**F**			**J**			Michener			Sabath			Weiss	
Camp			Faddis			Jackson			Mills of Arkansas			Sacks			Welch	
Canfield			Fellows			Jacobsen			Mills of Louisiana			Sanders			Wene	
Cannon of Florida			Fenton			Jarman			Mitchell			Sasscer			West	
Cannon of Missouri			Fish			Jarrett			Monroney			Satterfield			Wheat	
Capozzoli			Fitzgerald			Jenkins			Moser			Sauthoff			Whelchel	
Carlson			Fitzpatrick			Jenks			Mott			Scanlon			White	
Carter			Flaherty			Jennings			Mundt			Schaefer of Illinois			Whitten	
Cartwright			Flannagan			Jensen			Murdock			Schuetz			Whittington	
Case of South Dakota			Flannery			Johns			Murray			Schulte			Wickersham	
Casey of Massachusetts			Fogarty			Johnson of California			Myers of Pennsylvania						Wigglesworth	
Celler			Folger			Johnson of Illinois			**N**			Scott			Williams	
Chapman			Forand			Johnson of Indiana						Scrugham			Wilson	
Chenoweth			Ford, Leland M.			Johnson of Oklahoma			Nelson			Secrest			Winter	
Chiperfield			Ford, Thomas F.			Johnson, Luther A.			Nichols			Shafer of Michigan			Wolcott	
Clark			Ford of Mississippi			Johnson, Lyndon B.			Norrell			Shanley			Wolfenden	
Clason			Fulmer			Johnson of West Virginia			Norton			Shannon			Wolverton	
Claypool			**G**			Jones			**O**			Sheppard			Woodruff of Michigan	
Clevenger			Gale			Jonkman			O'Brien of Michigan			Sheridan			Woodrum of Virginia	
Cluett			Gamble			**K**			O'Brien of New York			Short			Worley	
Cochran			Gathings			Kean of New Jersey			O'Connor			Sikes			Wright	
Coffee of Nebraska			Gavagan			Kee of West Virginia			O'Day of New York						**Y**	
Coffee of Washington			Gearhart			Keefe of Wisconsin			O'Hara			Simpson			Young	
Cole of Maryland			Gehrmann			Kefauver			O'Leary						Youngdahl	
Cole of New York			Gerlach			Kelley of Pennsylvania			Oliver			Smith of Maine			**Z**	
						Kelly of Illinois			O'Neal			Smith of Ohio			Zimmerman	

" There are only two kinds of people who are staying on this beach—the dead and those who are going to die. Now let's get the hell off this beach!"
Col. George Taylor, commander of the 16th Regiment, 1st Infantry Division on Omaha Beach, D-day, June 6, 1944

The Army's First Infantry Division, nicknamed "The Big Red One" for the design of its insignia, was selected to be in the first wave of the Allied invasion of Nazi-occupied France during World War II. Maj. Gen. Clarence Huebner, who wore this helmet (opposite page) on D-day, was the division commander.

On June 6, the 1st Division's 16th Regimental Combat Team came ashore at the site designated Omaha Beach, a 4-mile stretch along the Normandy coast that saw the heaviest fighting and the greatest loss of life that day. The beach offered no cover, and retreat was impossible. Though pinned down by the fire at first, the men began to slowly make their way, amid the bloody chaos, across the beach, and up the hills to engage the enemy.

Huebner tried to monitor the action from the command ship, USS *Ancon*, but with the breakdown of communications, his orders were all but irrelevant by the time they were received. He

Helmet of Maj. Gen. Clarence Huebner, commander of the U.S. Army's First Infantry Division, which landed on Omaha Beach, D-day, June 6, 1944
National Archives, Dwight D. Eisenhower Presidential Library and Museum, Abilene, Kansas

came ashore at 7 P.M., helped to establish some degree of order, and set up a command post. He later received a Distinguished Service Medal for his "ability, foresight, indomitable determination and inspiring leadership" that contributed to the Allied advances at Normandy.

But the beaches that day belonged to the GIs, junior officers, and non-commissioned officers who somewhere in themselves found the raw courage to run straight into enemy fire and establish a beachhead for the drive across Europe in a campaign of liberation.

The Allied invasion at Normandy was the greatest amphibious attack in military history.

"It was over. I mean, it was quiet, as if nothing had happened. The beach was not any general's business. They had no say, none what-some-ever [sic]. It would've made no difference who commanded us in those first hours. None."
William Friedman, 16th Infantry Regiment, 1st Infantry Division, from the film "D-Day Remembered," a film by Charles Guggenheim, 1994

Background: "Landing on the coast of France under heavy Nazi machine gun fire are these American soldiers, shown just as they left the ramp of a Coast Guard landing boat," photograph by CphoM. (Chief Photographer's Mate) Robert F. Sargent, June 6, 1944
National Archives, Records of the U.S. Coast Guard [26-G-2343]

Order of Victory Award

"It had to be won, no matter what the sacrifices, no matter what the suffering to populations, to materials, to our wealth—oil, steel, industry—no matter what the cost—the war had to be won."

Gen. Dwight D. Eisenhower, Supreme Commander Allied Expeditionary Forces, 1945

Order of Victory, Soviet military award presented to Gen. Dwight D. Eisenhower, June 10, 1945
National Archives, Dwight D. Eisenhower Presidential Library and Museum, Abilene, Kansas

Eleven months after the Allies stormed the beaches at Normandy, the war in Europe ended with the total collapse of the Third Reich. Both the United States and the United Kingdom had overcome their profound ideological differences with the Soviet Union—a regime whose political purges killed millions of innocent Soviet citizens—to form an alliance that was instrumental in the defeat of Nazi Germany. Germany surrendered unconditionally on May 8, 1945.

During the June 10 victory celebration in Frankfurt, Germany, which was later described as "the zenith of Allied-Soviet cordiality," Soviet Marshal Georgy Zhukov presented this award to Gen. Dwight D. Eisenhower, supreme commander of the Allied forces in Europe. In one of history's great ironies, future U.S. President Eisenhower received the highest military decoration from the nation that would become America's adversary in the Cold War, a conflict which lasted 45 years and brought the world to the brink of nuclear war.

The medal is made of platinum, encrusted with 174 diamonds totaling 16 karats and 5 synthetic rubies. A raised image of the Kremlin is at the center of a blue enamel circle. The Russian letters "CCCP" (USSR) appear in white enamel at the top, and the Russian word for "Victory" appears at the bottom.

World War II remains the deadliest conflict of all time; it cost the lives of some 50 million people around the globe.

33

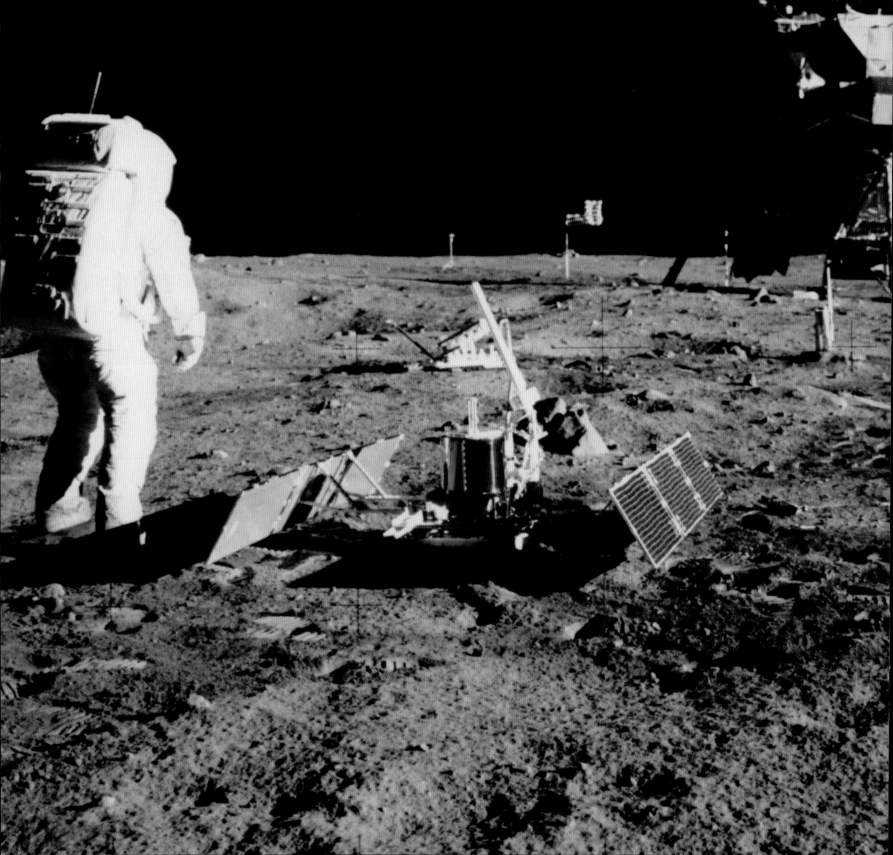

Lunar Excursion
MODULE

I n the 1950s the United States watched the Soviet Union take the lead in the rapidly escalating space race. The Soviet lead was both embarrassing and menacing to a nation that prided itself on technological know-how. In 1961 President John F. Kennedy challenged the nation to landing a man on the Moon and returning him safely to Earth before the end of the decade. The Apollo program was created to meet that goal.

"Astronaut Edwin E. Aldrin Jr., lunar module pilot, is photographed during *Apollo 11* extravehicular activity on the Moon," photograph by Astronaut Neil Armstrong, July 20, 1969. The Lunar Excursion Module appears in the far right background.
National Archives, Records of the U.S. Information Agency
[306-APAS11-F-40-5948]

"The Earth reminded us of a Christmas tree ornament hanging in the blackness of space. As we got farther and farther away, it [the Earth] diminished in size. Finally it shrank to the size of a marble, the most beautiful you can imagine."

Astronaut James Irwin, Lunar Module pilot, *Apollo 15*

The notion of humans walking on the Moon, once the stuff of science fiction, became a reality on July 20, 1969, when Neil Armstrong and Edwin E. "Buzz" Aldrin left the first human footprints on the lunar surface. It was an achievement of epic proportions, celebrated in the United States and in many parts around the world.

The Apollo program was one of the biggest technological endeavors ever undertaken by the Federal Government. It enlisted some 20,000 companies, hundreds of thousands of individuals in the government and private industry, and cost some $25 billion.

This globe, with a 74-inch diameter, incorporated the latest known data regarding the ocean's floor. With its contoured relief showing land and ocean features, including undersea mountain ranges, continental shelves, and oceanic ridges, it was considered an important contribution to the study of oceanography.

In 1969 it was presented as a gift to the National Archives from the Talbert and Leota Abrams Foundation to honor Antarctic explorers, U.S. Navy Capt. Finn Ronne and his wife, Edith Ronne. It was offered and accepted in the spirit of exploration with the hope that it would inspire appreciation of the geographic diversity and beauty of the planet.

The globe is now part of the National Archives' cartographic holdings along with 15 million maps, charts, aerial photographs, architectural drawings, patents, and ships' drawings.

Plastic globe, replica of planet Earth, created by Graham Gilmer and Frederic W. Dohr, Terr-A-Qua Globe & Maps Co., Inc., ca. 1969

National Archives, National Archives Gift Collection

This page and foldout: "Star-Forming Region LH95 in the Large Magellanic. Cloud," image taken with Hubble's Advanced Camera for Surveys, created for the National Aeronautics and Space Administration (NASA) by Space Telescope Science Institute (STScI), March 2006
Courtesy of the National Aeronautics and Space Administration (NASA), European Space Agency (ESA), and the Hubble Heritage Team (STScI/AURA)-ESA/Hubble Collaboration

This drawing represents a model of the Lunar Excursion Module, TM-1, that was inspected by NASA officials and astronauts in March 1964. Five years later, the Lunar Excursion Module, designated "Eagle," would detach from the command module of the *Apollo 11* spacecraft once it reached lunar orbit, carry two of the three astronauts to the Moon, and then blast back into lunar orbit to rejoin the command module which would carry all three astronauts back to Earth.

Gen. Douglas MACARTHUR'S
Military Personnel File

*"Let civilian voices argue the merits or demerits of our processes of government. . . .
Your guidepost stands out like a tenfold beacon in the night: Duty, Honor, Country."*
Gen. Douglas MacArthur, speech delivered to the Corps of Cadets at West Point, New
York, May 12, 1962

Personnel records of the men and women who have served in
the Armed Forces of the United States, even as far back as the
Revolutionary War, are maintained by the National Archives.
Generally, the records of those who have served during the 20th
century are at the National Personnel Records Center in St.
Louis, Missouri. The personnel file of Gen. Douglas MacArthur,
filling nine boxes, is among the biggest in the stacks.

Brig. Gen. Douglas MacArthur, August 1918
This photograph was taken during World War I, when MacArthur was serving in France and
first distinguished himself in combat as a military leader.
*National Archives, National Personnel Records Center (St. Louis, Missouri),
Records of the Army Staff*

Gen. Douglas MacArthur, July 1932
MacArthur served as Chief of Staff of the United States Army from 1930–35.
National Archives, National Personnel Records Center (St. Louis, Missouri),
Records of the Army Staff

Douglas MacArthur, one of America's great warriors, had a military career that spanned half a century and ranged around much of the world. He distinguished himself as a soldier in combat operations during World War I, rising to national prominence. He was the supreme allied commander, Southwest Pacific, during World War II, the supreme commander of the Allied Powers during the postwar occupation of Japan, and commander of the United Nations (U.N.) forces during the first nine months of the Korean War. Flamboyant and controversial, he was one of the most highly decorated soldiers in the history of the military. The documents on the following pages are from his official military personnel file. Box after box, thousands of pages of forms, photos, and other documentary fragments chronicle his extraordinary career.

The official military personnel file of Gen. Douglas MacArthur is housed in these boxes at the National Personnel Records Center in St. Louis, Missouri.
National Archives, National Personnel Records Center (St. Louis, Missouri), Records of the Army Staff

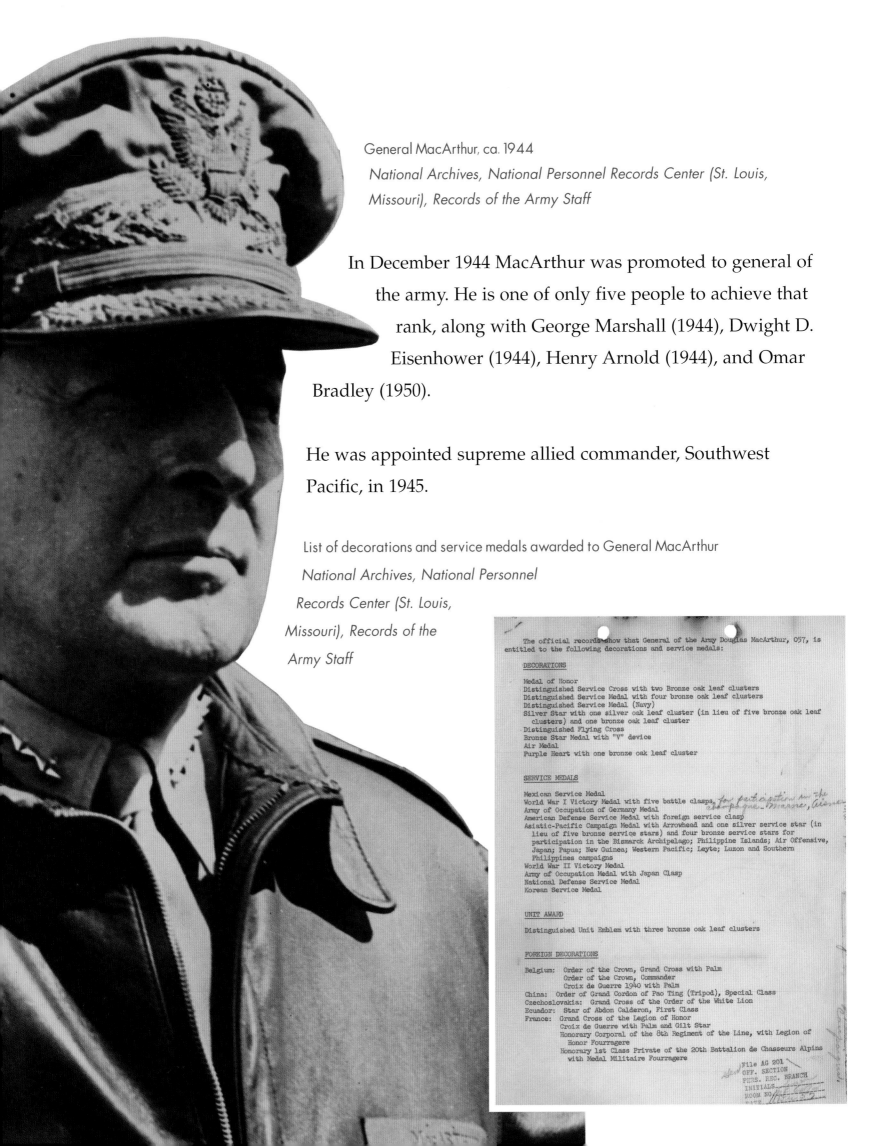

General MacArthur, ca. 1944

National Archives, National Personnel Records Center (St. Louis, Missouri), Records of the Army Staff

In December 1944 MacArthur was promoted to general of the army. He is one of only five people to achieve that rank, along with George Marshall (1944), Dwight D. Eisenhower (1944), Henry Arnold (1944), and Omar Bradley (1950).

He was appointed supreme allied commander, Southwest Pacific, in 1945.

List of decorations and service medals awarded to General MacArthur

National Archives, National Personnel Records Center (St. Louis, Missouri), Records of the Army Staff

The official records show that General of the Army Douglas MacArthur, O57, is entitled to the following decorations and service medals:

DECORATIONS

Medal of Honor
Distinguished Service Cross with two Bronze oak leaf clusters
Distinguished Service Medal with four bronze oak leaf clusters
Distinguished Service Medal (Navy)
Silver Star with one silver oak leaf cluster (in lieu of five bronze oak leaf clusters) and one bronze oak leaf cluster
Distinguished Flying Cross
Bronze Star Medal with "V" device
Air Medal
Purple Heart with one bronze oak leaf cluster

SERVICE MEDALS

Mexican Service Medal
World War I Victory Medal with five battle clasps, *for participation in the champagne, Marne, Aisne*
Army of Occupation of Germany Medal
American Defense Service Medal with foreign service clasp
Asiatic-Pacific Campaign Medal with Arrowhead and one silver service star (in lieu of five bronze service stars) and four bronze service stars for participation in the Bismarck Archipelago; Philippine Islands; Air Offensive, Japan; Papua; New Guinea; Western Pacific; Leyte; Luzon and Southern Philippines campaigns
World War II Victory Medal
Army of Occupation Medal with Japan Clasp
National Defense Service Medal
Korean Service Medal

UNIT AWARD

Distinguished Unit Emblem with three bronze oak leaf clusters

FOREIGN DECORATIONS

Belgium: Order of the Crown, Grand Cross with Palm
 Order of the Crown, Commander
 Croix de Guerre 1940 with Palm
China: Order of Grand Cordon of Pao Ting (Tripod), Special Class
Czechoslovakia: Grand Cross of the Order of the White Lion
Ecuador: Star of Abdon Calderon, First Class
France: Grand Cross of the Legion of Honor
 Croix de Guerre with Palm and Gilt Star
 Honorary Corporal of the 8th Regiment of the Line, with Legion of Honor Fourragere
 Honorary 1st Class Private of the 20th Battalion de Chasseurs Alpins with Medal Militaire Fourragere

File AG 201
OFF. SECTION
PERS. REC. BRANCH
INITIALS
ROOM NO.

Telegram from Gen. Omar Bradley, chairman of the Joint Chiefs of Staff, to Gen. Douglas MacArthur, conveying the message that President Harry S. Truman is relieving General MacArthur of his command in Korea, April 11, 1951, first page
National Archives, National Personnel Records Center (St. Louis, Missouri), Records of the Army Staff

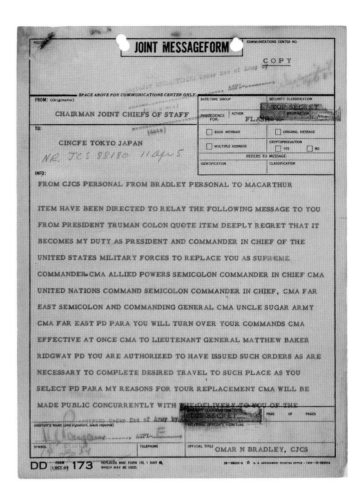

In June 1950, after North Korea invaded South Korea, MacArthur was designated commander of the United Nations Forces defending South Korea. He conceived and executed a brilliant and daring amphibious assault at Inchon for which he was hailed as a hero. Seven months later, President Truman fired him for making public statements that contradicted the official policies of the United States Government.

In a statement explaining this action, President Truman said:

It is fundamental . . . that military commanders must be governed by the policies and directives issued to them in the manner prescribed by our laws and Constitution. In time of crises this consideration is particularly compelling.

General MacArthur's place in history as one of our greatest commanders is fully established. The nation owes him a debt of gratitude for the distinguished and exceptional service which he has rendered his country in posts of great responsibility.

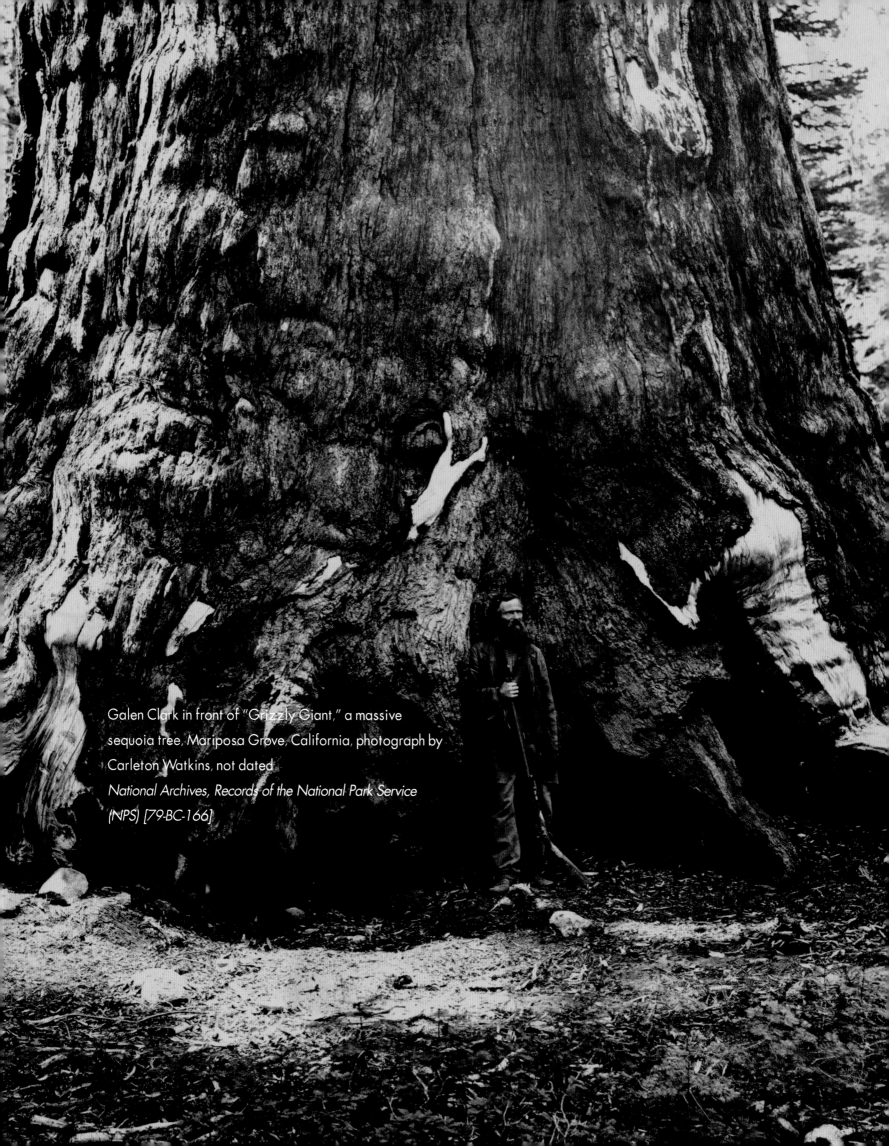

Galen Clark in front of "Grizzly Giant," a massive
sequoia tree, Mariposa Grove, California, photograph by
Carleton Watkins, not dated.
National Archives, Records of the National Park Service
(NPS) [79-BC-166]

MAMMOTH PRINTS
Early Photographs of Yosemite

So spectacular are the landscapes of California's Yosemite Valley that in 1861 San Francisco photographer Carleton Watkins invented a larger format to capture its vistas. During his first photographic expedition into the valley, he carried his custom-built, extra-large camera; "mammoth" glass-plate negatives, as they were called; and a portable darkroom. He emerged with approximately 30 stunning images of rock formations, waterfalls, and trees, whose clarity and beauty captured the public's imagination and brought him international acclaim. He returned several times over the next decade to photograph the natural wonders of Yosemite.

Watkins's images of Yosemite had a great impact on the movement to protect the area from commercial development. In 1864, in the midst of the Civil War, President Lincoln signed the "Yosemite Bill" to preserve the area, an important precedent in the eventual establishment of the National Park System.

Galen Clark, shown standing in front of the tree in the photograph on the facing page, first came upon a grove of some 200 giant sequoias in 1857 in what is now the southernmost part of Yosemite National Park; he named it Mariposa Grove and dedicated the rest of his life to its preservation.

The tree seen in the photograph is one of the oldest living trees in the grove, estimated at 2,700 years old. The tallest is approximately 290 feet and the largest measures approximately 40 feet in diameter. In total volume, the giant sequoia trees are the largest living things on earth.

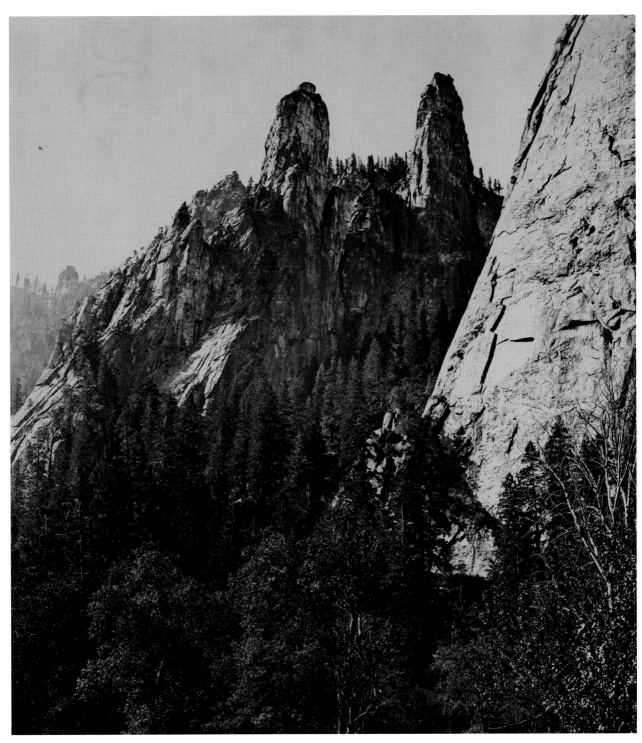

Cathedral Spires, Yosemite, California, photograph by Carleton Watkins, not dated
National Archives, Records of the National Park Service (NPS) [79-BC-162]

Right: Lower Yosemite Falls, California, photograph by Carleton Watkins, not dated
National Archives, Records of the National Park Service (NPS) [79-BC-153]

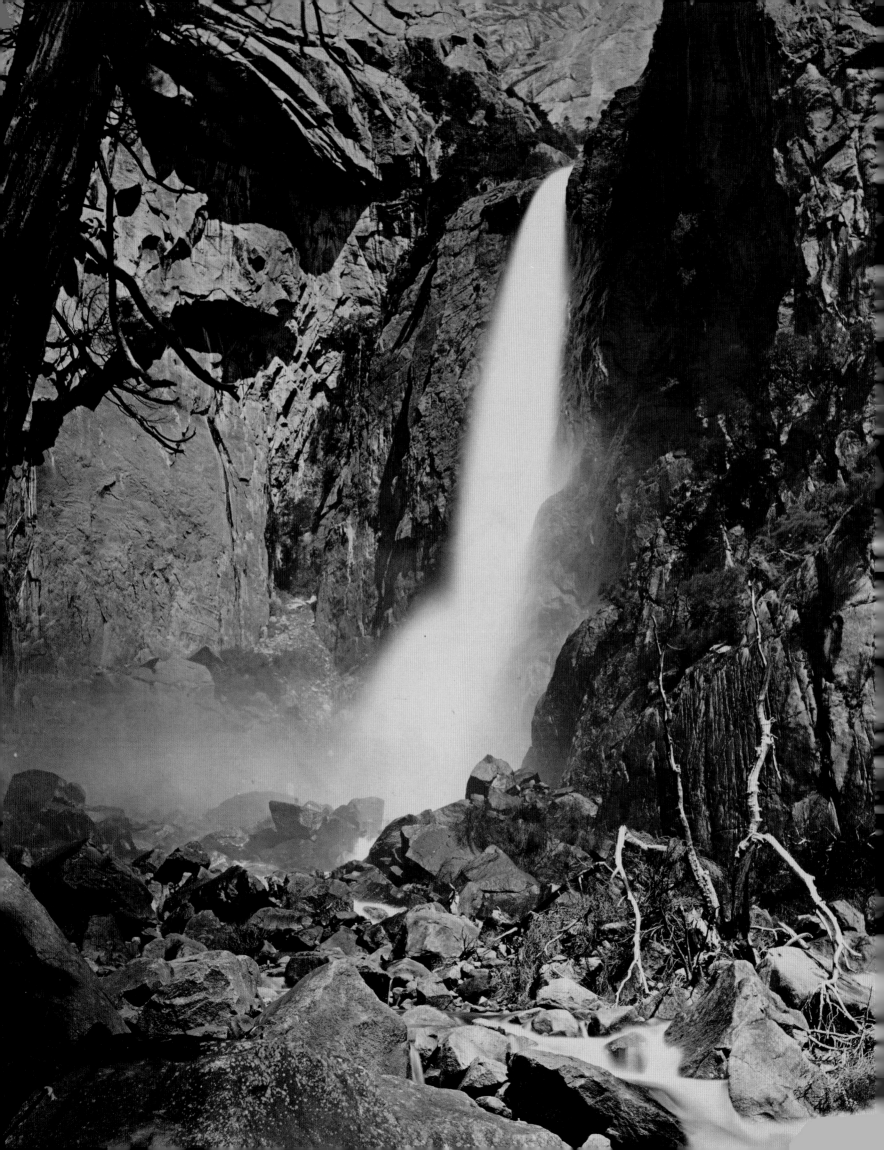

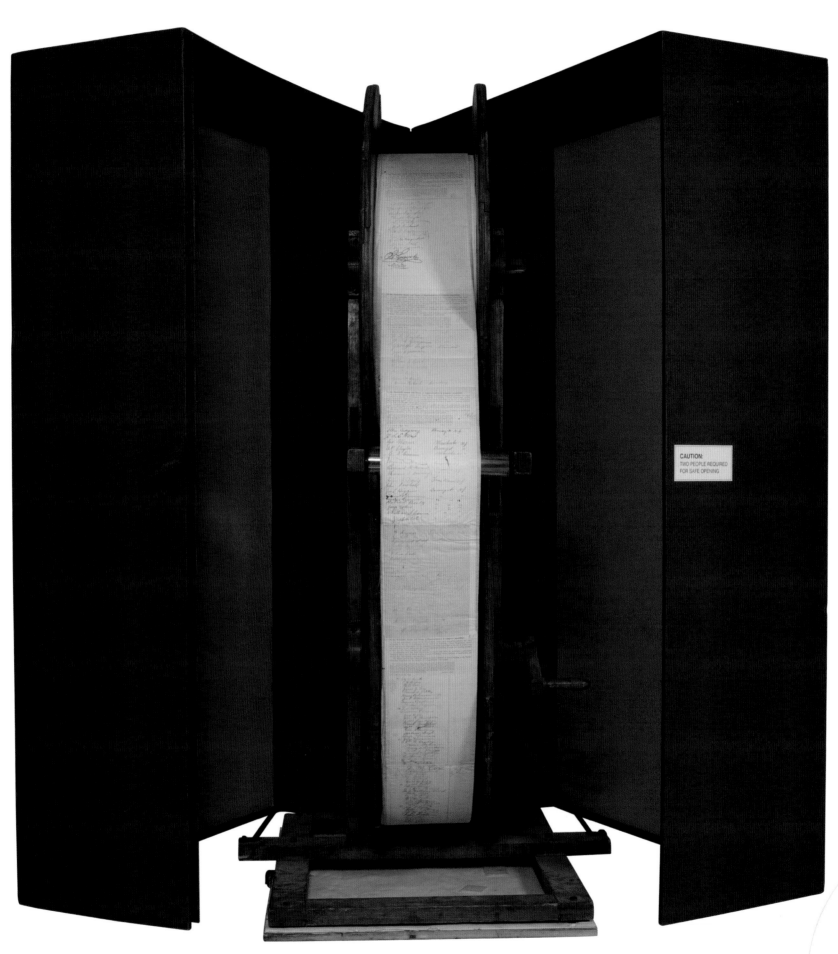

Petition for the Establishment of a Roads Department, presented in Congress, December 20, 1893

National Archives, Records of the United States Senate

Demand for BETTER ROADS

"Unclassable, almost unpassable, scarcely jackassable" was a popular slogan of the late 1800s describing the nation's pot-holed, muddy, unpaved, rutted roads. A new and increasingly popular mode of transportation, the bicycle, gave rise to a movement to improve the roads.

Col. Albert Pope, known as the founder of the American bicycle industry, circulated this petition that he hoped would lead to better roads. Printed sheets were distributed throughout the country and signed by approximately 150,000 people. They were attached and wound around two gigantic wooden spools, reminiscent of bicycle wheels, and carried to the Senate floor. On December 21, 1893, the *New York Times* reported that the petition was then "referred and wheeled to the Committee on Interstate Commerce."

At 5 feet 7 inches high, it is one of the largest petitions in the holdings of the National Archives. It is shown in its storage box (opposite page), designed and built by a conservation technician to protect it from dust, light, and contact damage, while also keeping it accessible for viewing. The box is made of paperboard and covered with book cloth.

the LONG Telegram

I n 1946, George Kennan, then deputy chief of mission of the United States to the Soviet Union, responded to an urgent communication from Washington, asking why the Soviet Union was refusing to join the World Bank. Kennan believed that the United States was clinging, mistakenly, to a wartime view of the Soviet Union as an American ally. He later recalled his reaction on receiving what he described as an "anguished cry of bewilderment" from his own government:

> *For two years, I [had] been trying to persuade people in Washington that the Stalin regime is the same regime we knew in the prewar period, the same one that conducted the purges . . . that its leaders are no friends of ours . . . that dreams of a happy postwar collaboration with this regime are quite unreal. . . . To explain all this, I [sat] down and drafted a preposterously long telegram—some eight thousand words . . . describing, as though in a primer for schoolchildren, the nature, the ambitions, the calculations of these men. It is a grim and uncompromising picture.*

Right: "Long Telegram" from George Kennan, chargé d'affaires, U.S. Embassy, Moscow, to Secretary of State James F. Byrnes, February 22, 1946, first page
National Archives, General Records of the Department of State

52

DEPARTMENT OF STATE

INCOMING TELEGRAM

~~TOP SECRET~~

PEM-K-M
No paraphrase necessary.

~~ET~~ *unclassified*

8963

Moscow via War

Dated February 2~~2 1946~~

Rec'd 3:52 p.m.

ACTION
INFO:
S
U
G
A-B
A-C
A-D
SA
SPA
UNO
EUR/X
EE/R

Secretary of State,

Washington.

511, February 22, 9 p.m.

Answer to Dept's 284, Feb 3 involves questions
so intricate, so delicate, so strange to our form of
thought, and so important to analysis of our inter-
national environment that I cannot compress answers
into single brief message without yielding to what
I feel would be dangerous degree of over-simplification.
I hope, therefore, Dept will bear with me if I submit
in answer to this question five parts, subjects of which
will be roughly as follows:

(One) Basic features of post-war Soviet outlook

(Two) Background of this outlook.

(Three) Its projection in practical policy on
official level.

(Four) Its projection on unofficial level.

(Five) Practical deductions from standpoint of
US policy.

I apologize in advance for this burdening of
telegraphic channel; but questions involved are of such
urgent importance, particularly in view of recent
events, that our answers to them, if they deserve atten-
tion at all, seem to me to deserve it at once. HERE
FOLLOWS PART ONE: BASIC FEATURES OF POST WAR SOVIET
OUTLOOK, AS PUT FORWARD BY OFFICIAL PROPAGANDA MACHINE,
ARE AS FOLLOWS:

(A) USSR still lives in antagonistic "capitalist
encirclement" with which in the long run there can be
no permanent peaceful coexistence. As stated by
Stalin in 1927 to a delegation of American workers

TOP SECRET

861.00/2-2246

In the telegram and a follow-up article that Kennan penned under the pseudonym "X" for *Foreign Affairs* magazine, he said that Soviet expansionism had to be contained, and he established guiding principles to achieve that goal. It was a grand strategy of such prescience and incisiveness that it carried American-Soviet policy through 40 years of the Cold War to the ultimate collapse of the Soviet Union in 1991. The "Long Telegram," as it is famously known, caused a sensation in the diplomatic and intelligence circles of official Washington and has since become an icon of American diplomatic history.

The telegram is 19 pages long.

"Long Telegram" from George Kennan, chargé d'affaires, U.S. Embassy, Moscow, to Secretary of State James F. Byrnes, February 22, 1946, signature page
National Archives, General Records of the Department of State

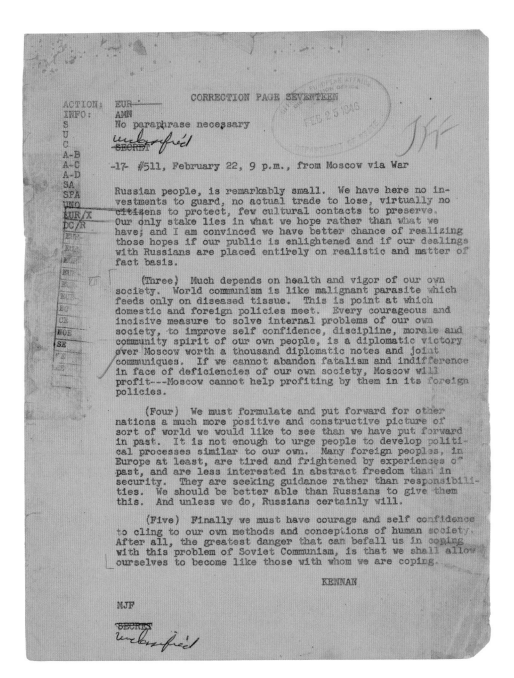

EXCERPTS FROM TELEGRAM

"At bottom of Kremlin's neurotic view of world affairs is traditional and instinctive Russian sense of insecurity. . . . And they have learned to seek security only in patient but deadly struggle for total destruction of rival power, never in compacts and compromises with it."

"In summary, we have here a political force committed fanatically to the belief that with US there can be no permanent modus vivendi, that it is desirable and necessary that the internal harmony of our society be disrupted, our traditional way of life be destroyed, the international authority of our state be broken, if Soviet power is to be secure."

"Much depends on health and vigor of our own society. World communism is like malignant parasite which feeds only on diseased tissue."

"Finally we must have courage and self confidence to cling to our own methods and conceptions of human society. After all, the greatest danger that can befall us in coping with this problem of Soviet Communism, is that we shall allow ourselves to become like those with whom we are coping."

55

An Even LONGER Telegram: Nevada State Constitution

Twice the length of George Kennan's 1946 "Long Telegram," this message, originally transmitted in Morse Code, contains the entire text of the Nevada State Constitution. With no direct link from Carson City to Washington, DC, telegrapher James H. Guild worked 7 hours to transmit the message to Salt Lake City, where it was sent to Chicago, then Philadelphia, and finally to the War Department's telegraph office in Washington, DC, where this transcription was made. The final page shows the total word count (16,543) and cost ($4303.27—or $59,229 today) of the transmission.

In the midst of the Civil War, President Abraham Lincoln eagerly sought the statehood of the pro-Unionist and largely Republican Nevada. Certified copies of the Nevada Constitution, sent earlier by overland mail and by sea, had failed to arrive in Washington, DC, by October 24, so Governor Nye of the Nevada Territory ordered that it be sent by wire. Three days after receiving this telegram—just eight days before the Presidential election—Lincoln proclaimed, in accordance with an act of Congress, that Nevada was admitted into the Union, thus hoping to ensure his own re-election, as well as the election of like-minded Republicans in Congress.

The transcription of the message is 175 pages.

Right: Telegraph from James W. Nye, governor of the Territory of Nevada, to President Abraham Lincoln, October 26, 1864; received October 28, 1864, selected pages
National Archives, General Records of the Department of State

56

'Cd

Office U. S. Military Telegraph,
WAR DEPARTMENT.

The following Telegram received at Washington, 10 45 P M. Oct 28 1864.

63 From Carson City, Nevada Ty Oct 26 1864.

His Excy Abraham Lincoln

Official — The Constitution of the State of Nevada together with the Resolutions & Ordinances as passed by the State Constitutional Convention Thursday July twenty eighth Eighteen hundred sixty four

Resolution adopting the Constitution of the United States

Whereas the act of Congress March twenty first 20 to enable the people of Territory of Nevada to form a Constitution & State into the Union on an equal footing with original States represented by the members of the Convention framing Said Constitution shall after

The seal of the Territory of Nevada this Seventeenth day of October Eighteen hundred & Sixty four 1864

James W. Nye
Govr of the Territory of Nevada

Attest
Orion Clemens
Secy of the Territory of Nevada

(Seal)

6543. Nd.
Recd No 4303.27

One Hundredth Congress of the United States of America

AT THE FIRST SESSION

*Begun and held at the City of Washington on Tuesday, the sixth day of January,
one thousand nine hundred and eighty-seven*

Joint Resolution

Making further continuing appropriations for the fiscal year 1988, and for other
purposes.

*Resolved by the Senate and House of Representatives of the United
States of America in Congress assembled,*

SEC. 1. Because the spending levels included in this Resolution achieve the deficit reduction targets of the Economic Summit, sequestration is no longer necessary. Therefore:

(a) Upon the enactment of this Resolution the orders issued by the President on October 20, 1987, and November 20, 1987, pursuant to section 252 of the Balanced Budget and Emergency Deficit Control Act of 1985, as amended, are hereby rescinded.

(b) Any action taken to implement the orders referred to in subsection (a) shall be reversed, and any sequesterable resource that has been reduced or sequestered by such orders is hereby restored, revived, or released and shall be available to the same extent and for the same purpose as if the orders had not been issued.

The following sums are hereby appropriated, out of any money in the Treasury not otherwise appropriated, and out of applicable corporate or other revenues, receipts, and funds, for the several departments, agencies, corporations, and other organizational units of the Government for the fiscal year 1988, and for other purposes, namely:

[1] SEC. 101. (a) Such amounts as may be necessary for programs, projects or activities provided for in the Departments of Commerce, Justice, and State, the Judiciary, and Related Agencies Appropriations Act, 1988 at a rate of operations and to the extent and in the manner provided for, the provisions of such Act to be effective as if it had been enacted into law as the regular appropriations Act, as follows:

ENROLLMENT ERRATA

Pursuant to the provisions of section 101(n) of this joint resolution (appearing on page 433), changes made are indicated by footnote.

The words "Government", when referring to the Government of the United States will be capitalized, "Act", if referring to an action of the Congress of the United States, will be capitalized, "State", when referring to a State of the United States will be capitalized, "title" and "section" will be lower case, when referring to the United States Code or a Federal law. The capitalization of the foregoing words may be changed, and not footnoted.

[1] Copy read "(a) Such amounts".

A BIG LAW—
PUBLIC LAW 100-202

"Broken down" is the way President Ronald Reagan described the Federal budget process of Fiscal Year 1988, which ended with his signing this behemoth 1,056-page law—a continuing resolution that would fund the Federal Government's activities over the next 9 months.

President Reagan submitted his budget to Congress on January 5, 1987. Congress had until October 1, the start of the new fiscal year, to enact 13 appropriations bills. But, as the fiscal year ended, none of the 13 had been passed. Finally, as the last of four stop-gap funding measures expired in the wee hours of December 22, 1987, Congress reached agreement. This one gigantic bill, combining all 13 appropriations bills, is the culmination of a full year's legislative work, made up of thousands of separate budget and policy decisions and compromises, each holding major significance for some segment of the American citizenry. The law, formulated to help reduce the Federal deficit, authorized $603.9 billion in Federal spending for the remaining months of Fiscal Year 1988. It was the third time in history that all 13 appropriations bills were lumped together in one large bill.

The law, which fills these four boxes, is preserved and stored in the National Archives Building in Washington, DC, along with all the laws of the United States from 1789 through 2006.

Left: Public Law 100-202, passed by Congress and signed by President Ronald Reagan, December 22, 1987, selected pages
National Archives, General Records of the United States Government

59

President Reagan, delivering his State of the Union Address, photograph by Susan Biddle, January 25, 1988

In his final State of the Union Address, just one month after signing this massive law, President Reagan said that the budget process needed a "drastic overhaul." A master of political theater, he brought to the podium physical evidence of the disrepair of the budget process: 43 pounds of paper, including the full text of this continuing resolution. He said that "it took 300 people at my Office of Management and Budget just to read the bill so the government wouldn't shut down."

National Archives, Ronald Reagan Presidential Library and Museum, Simi Valley, California [NLRR C44969-32]

H.J. Res. 395--1056

``(1) provide notice of the proposed guideline to nonprofit voluntary agencies and cooperatives that participate in programs under this title, and other interested persons, that the proposed guideline is available for review and comment;

``(2) make the proposed guideline available, on request, to the agencies, cooperatives, and others; and

``(3) take any comments received into consideration before the issuance of the final guideline.

``(c) DEADLINE FOR SUBMISSION OF COMMODITY ORDERS.--Not later than 15 days after receipt of a call forward from a field mission for commodities or products that meets the requirements of this title, the order for the purchase or the supply, from inventory, of such commodities or products shall be transmitted to the Commodity Credit Corporation.''.

Speaker of the House of Representatives.

~~Vice President of the United States and~~
Acting President of the Senate pro tempore

APPROVED

DEC 22 1987

Ronald Reagan

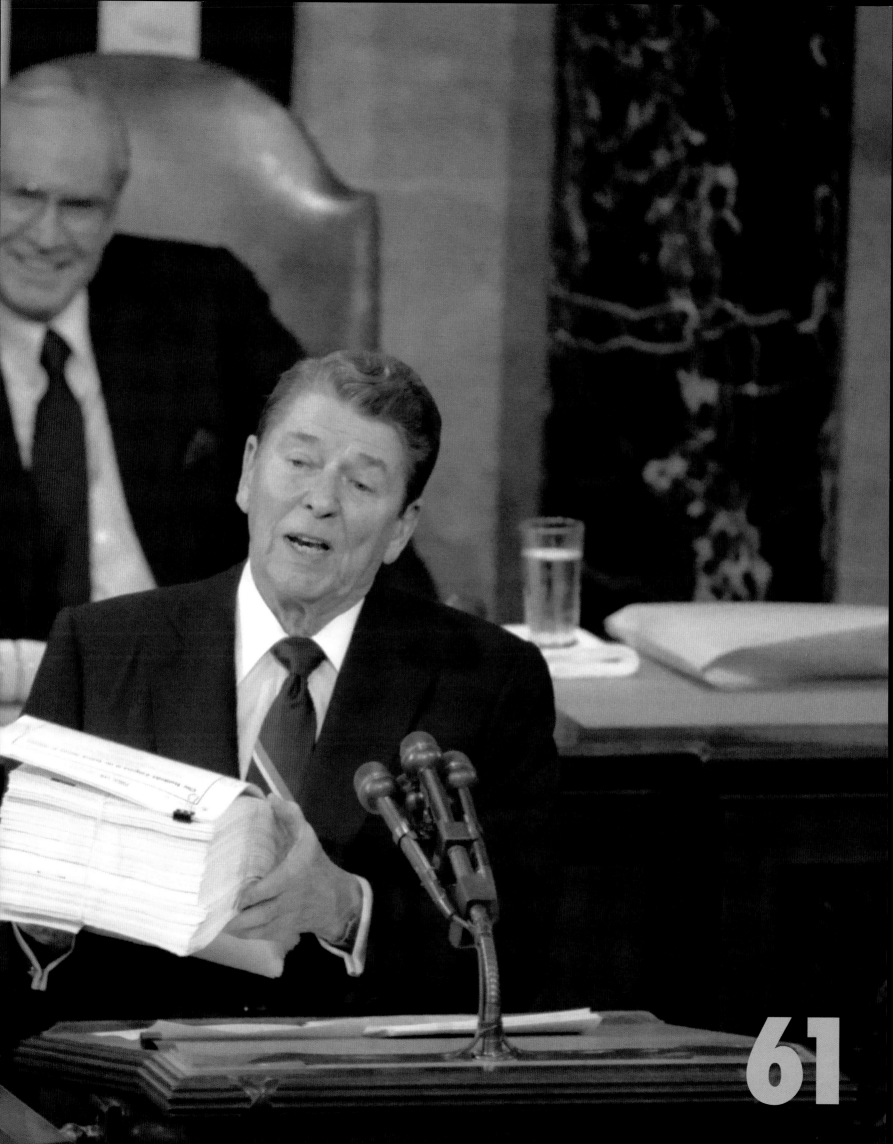

61

PRESIDENT
William Howard Taft

Even in an era before obesity became a national health concern, President William Howard Taft seemed larger than life. During his Presidency, 1909–13, the 340 pounds on his 5-foot-11 ¹/₂-inch frame made him an imposing figure and, at times, the subject of ridicule. (Once, while serving as the first civil governor in the Philippine Islands, he cabled the secretary of state, reporting on a 25-mile horseback ride in the mountains, only to receive in response a cable inquiring, "Referring to your telegram . . . how is horse?")

There are poignant accounts of the health problems President Taft experienced as a result of his obesity: he would often fall asleep at public functions, "pant for breath at every step," as a close aide privately observed, and not appear to be mentally alert, particularly after meals.

Although Taft's life predates a time when special accommodations for large people were common, adjustments were made for him as President-elect. In January 1909, two months after being elected President, Taft boarded the USS *North Carolina* to set sail to inspect the Panama Canal construction zone; the ship was specially outfitted just for him.

Right: Letter from Capt. W. A. Marshall to commandant of the Navy Yard, requesting items for the USS *North Carolina*, in preparation for President-elect Taft's voyage, December 21, 1908
National Archives, Records of the Bureau of Supplies and Accounts (Navy)

BN-186
 1-encl.

U. S. S. North Carolina,

Hampton Roads, Va.,

December 21, 1908.

Sir:--

In accordance with Department's communication #6166-32 of the 19th instant, copy attached, I have to request that pending the return, on or about January 6th, 1909, of this vessel from present assigned duty, the following articles, necessary to fit up quarters to be occupied by the President-elect, be provided:

1 Brass double bedstead, of extra length.

1 Superior spring mattress, extra strong.

1 Superior hair mattress.

2 Superior hair pillows.

1 Bolster.

1 Bath tub, 5feet 5 inches in length, over rolled rim,

and of extra width.

Respectfully,

W. A. Marshall

Captain, U.S.Navy,
Commanding.

The Commandant,

Navy Yard, Norfolk.

(Department of Donstruction & Repair.)

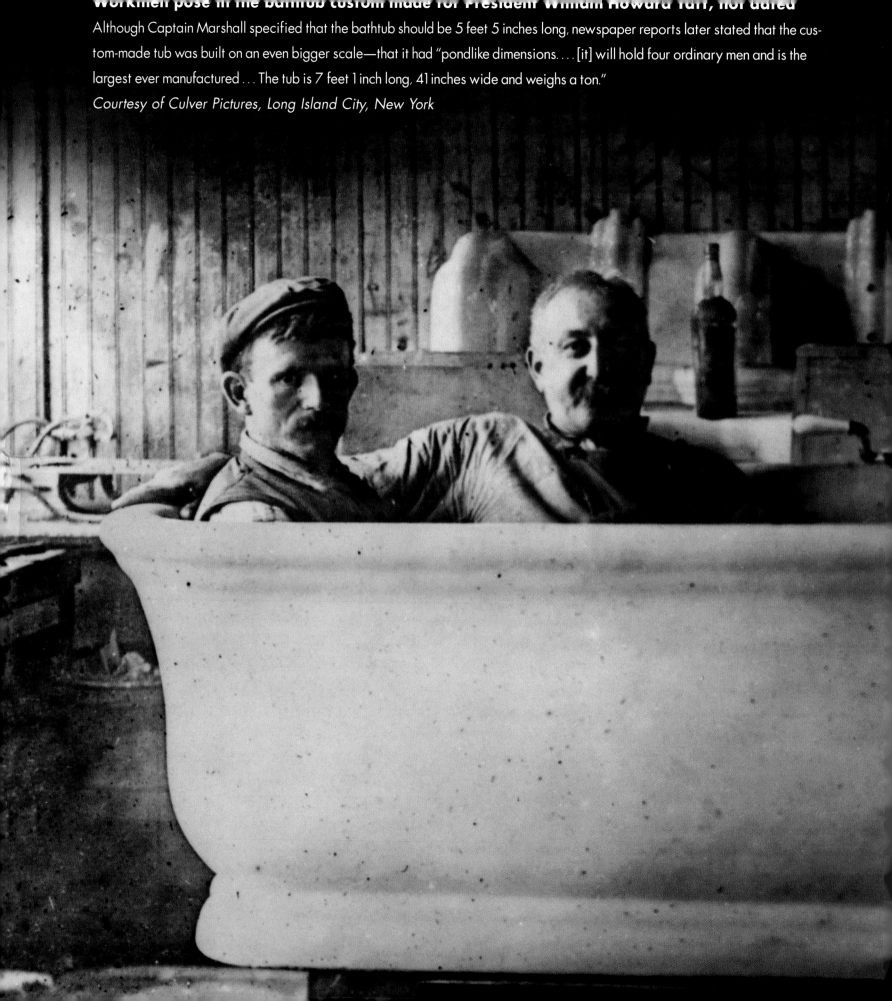

Workmen pose in the bathtub custom made for President William Howard Taft, not dated

Although Captain Marshall specified that the bathtub should be 5 feet 5 inches long, newspaper reports later stated that the custom-made tub was built on an even bigger scale—that it had "pondlike dimensions. . . . [it] will hold four ordinary men and is the largest ever manufactured . . . The tub is 7 feet 1 inch long, 41 inches wide and weighs a ton."

Courtesy of Culver Pictures, Long Island City, New York

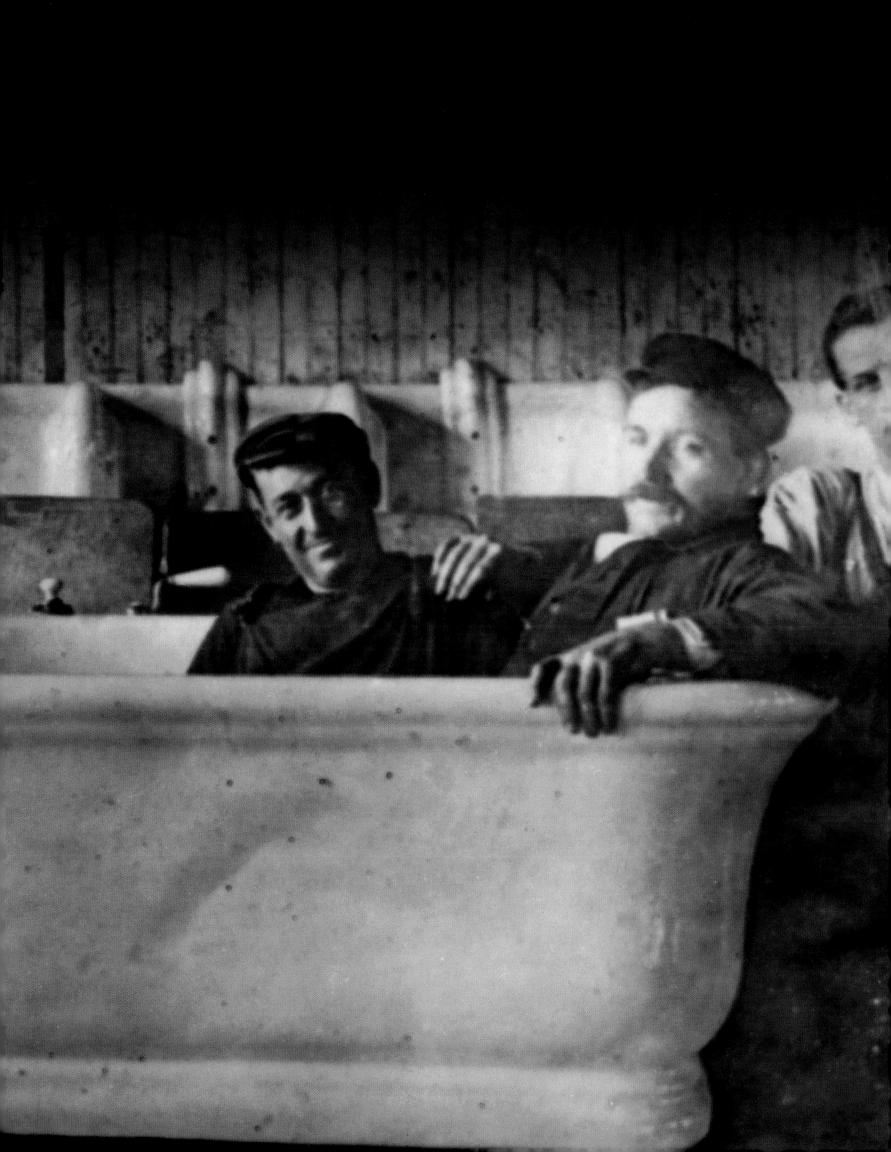

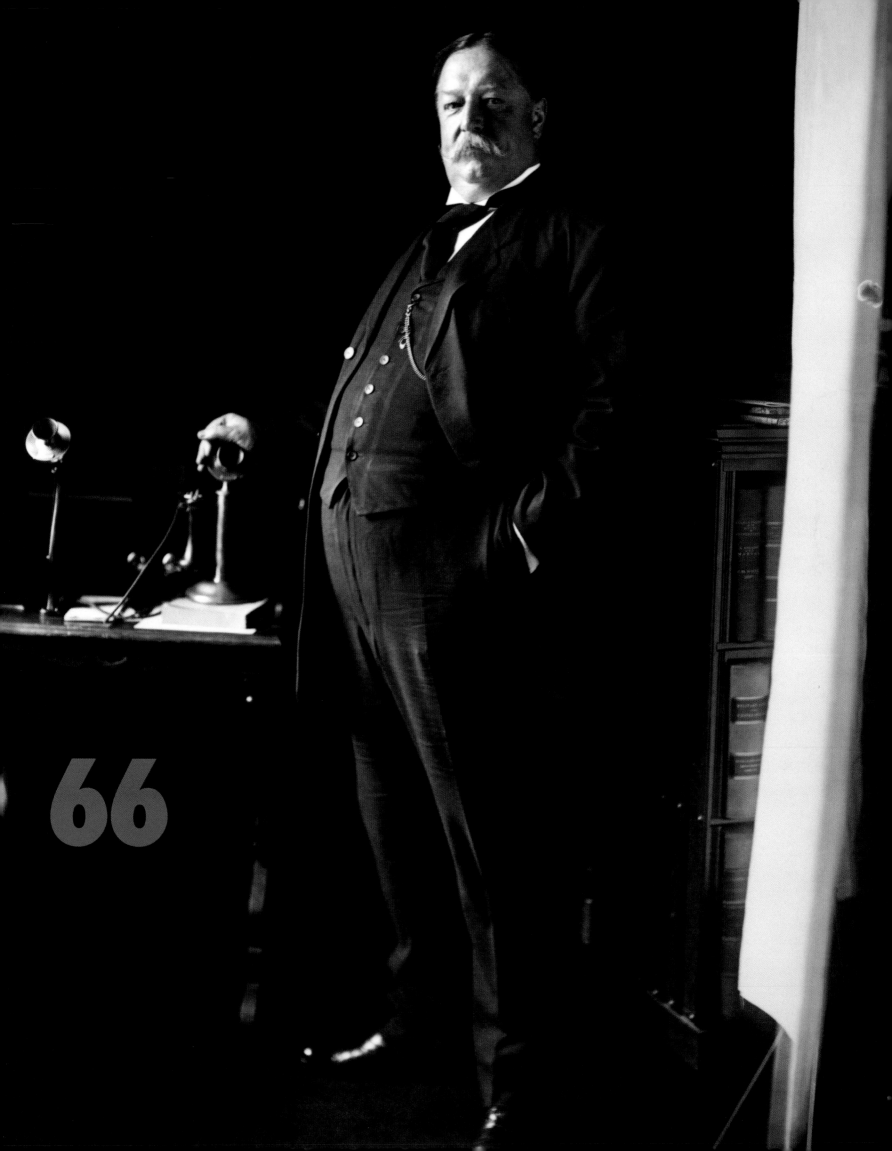

66

William Howard Taft, 1908

Taft had a long and distinguished career in public service before he was elected President, serving as judge, solicitor general of the United States, civil governor of the Philippine Islands, and secretary of war. He loved the law and his highest ambition was to serve on the Supreme Court. Biographers speculate that his obesity, which peaked during his Presidency (340 pounds), was linked to his emotional discontent with occupying the office. Kind, good-natured, and eager to please, he detested the rough-and-tumble of Presidential politics and was not a good politician. In spite of the personal difficulties he faced during his years in the White House, his administration initiated 80 antitrust suits, strengthened the Interstate Commerce Commission, and improved the national postal system.

Courtesy of the Library of Congress, Prints and Photographs Division, Washington, DC [LC-USZ62-7757]

William Howard Taft (front row, center) as chief justice of the Supreme Court, 1925

Nine years after being soundly defeated in the election of 1912, Taft's lifelong dream was fulfilled when President Warren Harding appointed him chief justice of the Supreme Court. The former President served on the High Court until just weeks before his death in 1930. Taft is the only person to hold the highest office in both the executive and judicial branches.

Less than a year after leaving the Presidency, Taft achieved a weight loss of 70 pounds, which he maintained throughout the remainder of his life.

Courtesy of the Library of Congress, Prints and Photographs Division, Washington, DC
[LC-USZ62-12566]

HOW DID HE DO IT?

Nine months after he left office, Taft talked about his dramatic weight loss in a story that appeared on the front page of the *New York Times*:

I can truthfully say that I never felt any younger in all my life. Too much flesh is bad for any man. . . .

. . . I have dropped potatoes entirely from my bill of fare, and also bread in all forms. Pork is also tabooed, as well as other meats in which there is a large percentage of fat. All vegetables except potatoes are permitted, and of meats, that of all fowls is permitted. In the fish line I abstain from salmon and bluefish, which are the fat members of the fish family. I am also careful not to drink more than two glasses of water at each meal. I abstain from wines and liquors of all kinds, as well as tobacco in every form.

69

Senate Investigation into JUVENILE DELINQUENCY

" We are going to pay particular attention to ideas that spring into the living room on 32 million television sets and into the minds of our children."

Senator Robert C. Hendrickson, chairman of the Senate subcommittee investigating juvenile delinquency, October 19, 1954

With a dramatic upsurge in youth crime during the 1950s, a new menace began to haunt the nation's psyche: the American juvenile delinquent. In 1953, FBI Director J. Edgar Hoover reported that "persons under the age of 18 committed 53.6 percent of all car thefts, 49.3 percent of all burglaries, 18 percent of all robberies, and 16.2 percent of all rapes."

As juvenile crime escalated and became a national concern, the Senate undertook an investigation to determine the cause of this disturbing trend and to identify steps the Government might take to reverse it. This chart was presented to illustrate how much television programming was centered on the themes of crime and violence. The portions marked in red indicate crime programs.

Even with its crime-doesn't-pay morality message, *Dragnet*, a favorite program of elementary school children, was thought to have a negative effect on the nation's youth.

Right: Chart showing a day of television programming in Chicago, September 16, 1954, presented as an exhibit during a Senate investigation on juvenile delinquency
National Archives, Records of the United States Senate

70

CHICAGO, ILL. T-V
THURSDAY · SEPT. 16, 1954

	WGN	WBKB	WNBQ	WBBM
4 :00	BANDSTAND MATINEE	PIED PIPER	PINKY LEE	SHOPPING WITH MISS. LEE
:15	"	"	"	"
:30	"	GARFIELD GOOSE	HOWDY DOODY	LOOKING FORWARD
:45	"	"	"	"
5 :00	BOB ATCHER WESTERN	JUNGLE ADVENTURE	ELMER - J. CONRAD	RANGE RIDER
:15	"	"	"	"
:30	NEWS	NEWS	CLOSE-UP	GENE AUTRY
:45	NOW I'LL TELL ONE ERNIE SIMON	SPORTS + WEATHER	"	"
6 :00	CAPTAIN VIDEO	KUKLA, FRAN + OLLIE	NEWS, WEATHER + SPORTS	SPORTS
:15	VINCE LLOYD	NEWS	D. CONNORS · TRAVEL. NEWS	NEWS
:30	"	LONE RANGER	VAUGHN MONROE	NEWS
:45	NEWS	"	NEWS	JANE FROMAN
7 :00	THEY STAND ACCUSED	NEWS	GROUCHO MARX	RAY MILLAND
:15	"	"	"	"
:30	"	MELODY TOUR	JUSTICE	4·STAR PLAYHOUSE
:45	"	"	"	"
8 :00	BEHOLD THY MOTHER	SO YOU WANT TO LEAD A BAND	DRAGNET	PANEL QUIZ
:15	"	"	"	"
:30	HOME SWEET HOME	THEATRE DRAMA	THEATRE	BIG TOWN
:45	"	"	"	"
9 :00	THE LONE WOLF	"	VIDEO THEATRE	TELL TALE CLUE
:15	"	"	"	"
:30	BOSTON BLACKIE	VICTORY AT SEA DOCUMENTARY	"	NAME THAT TUNE
:45	"	"	"	"
10:00				

PRESIDENTIAL PHOTOGRAPH AND FLAG OF
John F. Kennedy

Background: Copper printing plate of President John F. Kennedy's portrait, photograph by Fabian Bachrach, 1960

National Archives, John F. Kennedy Presidential Library and Museum, Boston, Massachusetts

The photograph selected to be President John F. Kennedy's official portrait after the 1960 election was actually taken during the campaign, while Kennedy was serving as U.S. senator from Massachusetts. In a photo session that took place in his Senate office and lasted less than one hour, Kennedy seemed anxious to move on to more important business. The photographer later recalled in a *Saturday Evening Post* article: "He's co-operative, but when he sat down and said, 'Is this all right?' I knew that pose was what I was going to get. You wouldn't think of asking him to move into a certain position or tilt his head."

This image was displayed in Federal buildings and circulated to the general public as the President's official portrait throughout the years of the Kennedy administration.

President John F. Kennedy's portrait, photograph by Fabian Bachrach, 1960

National Archives, John F. Kennedy Presidential Library and Museum, Boston, Massachusetts

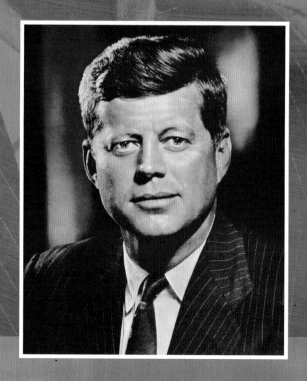

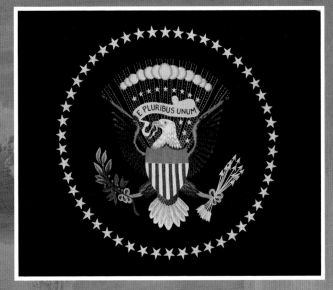

Presidential flag displayed in the West Wing of the White House during the Presidency of John F. Kennedy

In December 1963, the month following the assassination of President Kennedy, Jacqueline Kennedy presented this flag to Lawrence F. O'Brien, Jr., who had served as special assistant to the President for congressional relations.

The Presidential flag has a dark blue field and features the spread-eagle figure of the Great Seal of the United States. The eagle holds arrows to symbolize power and an olive branch to symbolize peace. In the eagle's beak is a white scroll with the Latin words, "E Pluribus Unum," ("Out of Many, One") a motto originally proposed in 1776 by Thomas Jefferson, Benjamin Franklin, and John Adams. The 50 stars encircling the eagle symbolize the 50 states.

Courtesy of Lawrence F. O'Brien III, Washington, DC

NATIONAL ARCHIVES BUILDING

In 1810, a congressional committee found that the Federal Government was not taking good care of its records; it found them to be "in a state of great disorder . . . and in a situation neither safe nor honorable to the nation." After 124 years of Presidential commissions, congressional attempts, and finally, pressure from America's historians, Congress created the National Archives in 1934 to be the Government's official record keeper. The National Archives holds in trust for the American people the permanently valuable records of the United States. For 75 years, the National Archives has preserved and provided access to the official records of the United States.

Architect John Russell Pope designed the National Archives Building to reflect the high purpose of the National Archives' mission. On laying the cornerstone in 1933, President Herbert Hoover described it as "a temple of our history . . . one of the most beautiful buildings in America, an expression of the American soul." The building was designed in the style of a Greek temple, ornamented and surrounded by four sculptures that represent the Future, Past, Heritage, and Guardianship.

Pope designed the building on a monumental scale. This sheet shows, some of the letters used to spell out the name "ARCHIVES OF THE UNITED STATES OF AMERICA" that appears above the building's two entrances. Each letter is 25 inches high.

Right: Detail of diagram of letters and spacing, full-scale, used in the inscription "ARCHIVES OF THE UNITED STATES OF AMERICA" above the two entrances to the National Archives Building, Washington, DC, 1934

National Archives, Records of the Public Buildings Service

74

¢ OF INSCRIPTION & FOR

MEASURING LINE

MEASURING LINE

MEASURING LINE

LINE OF LETTERS

75

Facts about the National Archives Building:

Length: 330 feet (from 7th to 9th Streets)

Width: 213 feet (from Pennsylvania Avenue to Constitution Avenue)

Height: 166 feet

Storage Space: This building contains 650,000 cubic feet of records storage space.

Bronze Doors: Each of the doors weighs 6 $\frac{1}{2}$ tons; each measures 38 feet 7 inches high, nearly 10 feet wide, and 11 inches thick. When the building was constructed in the 1930s, these doors were described as the largest in the world.

A New Building: To accommodate the ever-growing volume of historically significant Federal records, the National Archives at College Park, Maryland (Archives II), a state-of-the-art archival facility, was opened in 1994, adding approximately 2 million cubic feet of records storage space.

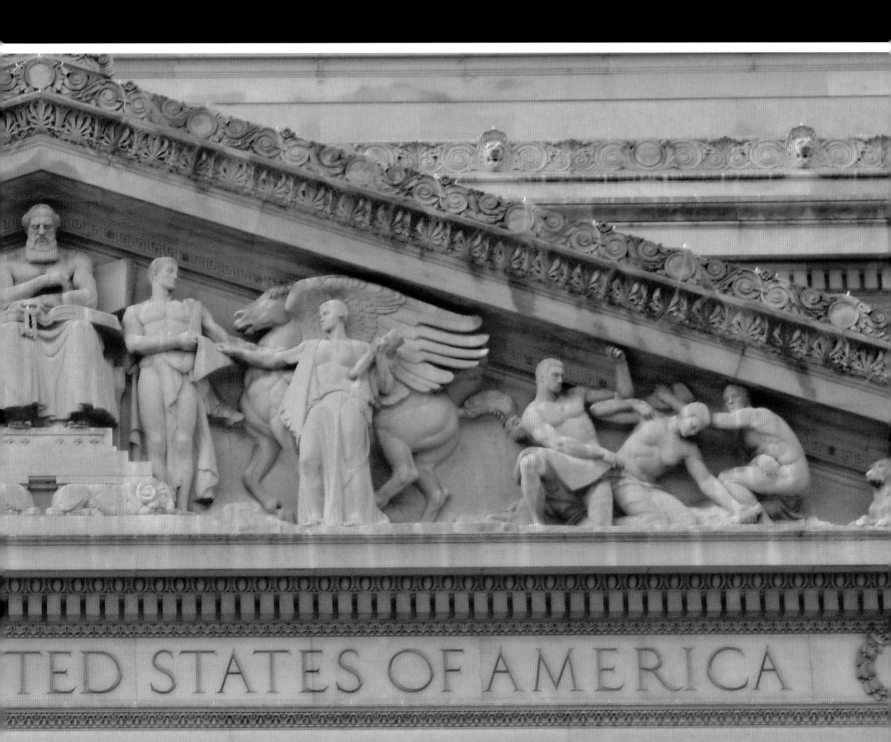

"SHAQ" Shoe

Rising up out of this shoe, Shaquille O'Neal ("Shaq" as he is affectionately known by his fans) would stand tall at 7 feet 1 inch. He was a star basketball player for the Los Angeles Lakers in 2001 when President George W. Bush made his first visit to California as President. As a welcoming gesture, Los Angeles Mayor Richard Riordan gave O'Neal's shoes—this one signed by "Shaq" himself—to the President, saying, "You can use them as skis or carry-on bags when you travel on Air Force One." This image of the shoe is reproduced here in its actual size.

Shaquille O'Neal has been voted one of the 50 greatest players in the history of the National Basketball Association (NBA).

Shoe of Shaquille O'Neal, size 22 medium, presented as a gift to President
George W. Bush, May 31, 2001
*National Archives, George W. Bush Presidential Library
and Museum*

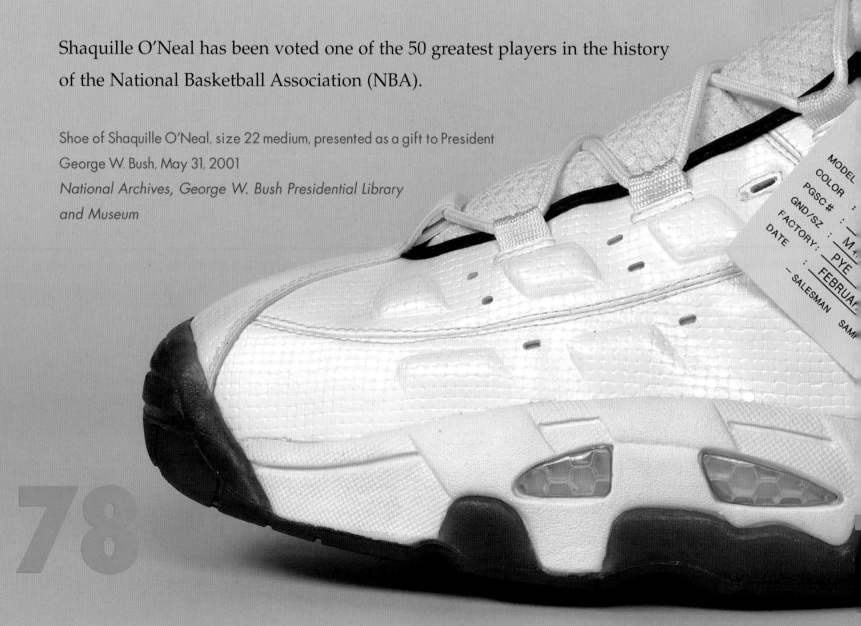

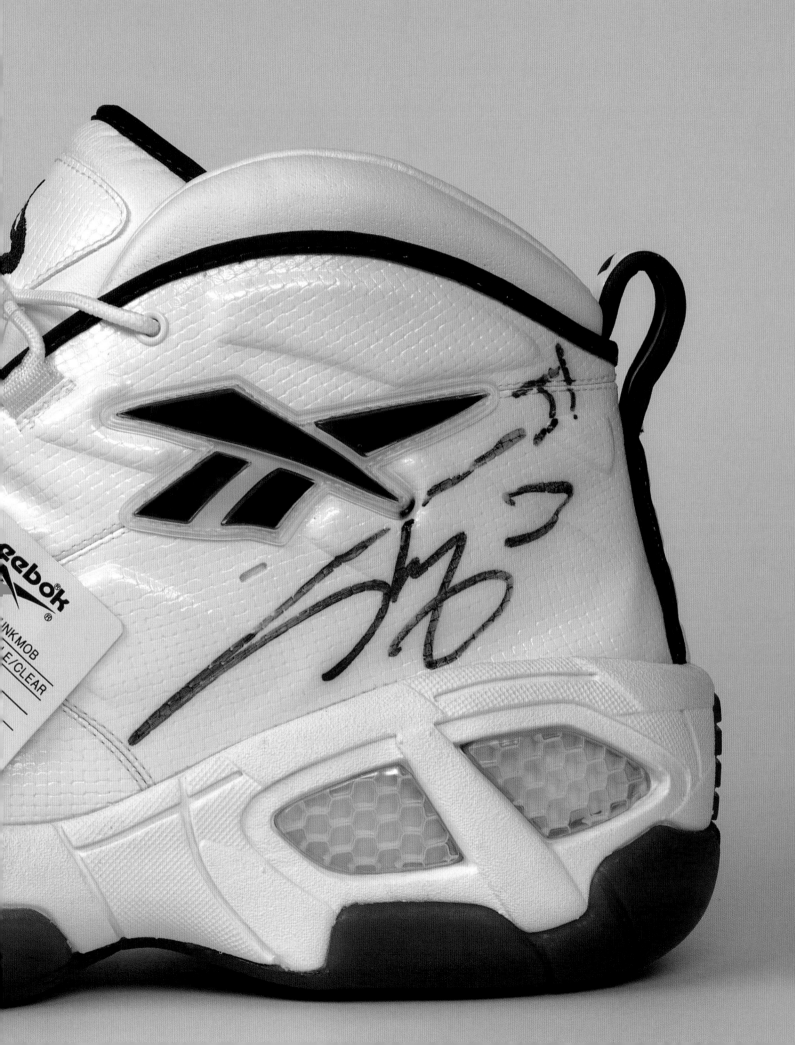

SS LEVIATHAN

"Leviathan. It's in the Bible, monster of the deep."
Attributed to President Woodrow Wilson, on the renaming of
the great German ship, *Vaterland*

This painting, made on one continuous piece of paper, depicts the 1922–23 restoration of the ship that was advertised as "the largest ship in the world." She was 950 feet long and 8 stories high. As a troop transport during World War I, the ship once carried 14,416 people, more human beings than had ever before sailed on a single vessel. After her 1922–23 reconditioning that included a shift from coal to oil fuel, the *Leviathan* burned 2,811,522 gallons of oil in a single transatlantic crossing.

Built in 1914 by the German Hamburg-American Line as a spectacular luxury liner named *Vaterland* (German for "Fatherland"), she was seized by the American government in 1917 as the United States entered World War I, renamed *Leviathan,* and converted into a troop transport ship that carried approximately 120,000 American servicemen to the combat zone during the war years.

Following World War I, she was again reborn as an American super luxury liner, after a massive refitting that is meticulously articulated in this drawing, featuring wood-paneled saloons, a swimming pool, and a dining room modeled on that of New York's Ritz-Carlton Hotel. The SS *Leviathan*, the epitome of elegance, operated as a transatlantic passenger liner from 1923 until 1934. When she ceased to be profitable during the Great Depression, she was sold to Scottish ship breakers, and in 1938 the mighty ship was scrapped.

This painting is among the National Archives' cartographic and architectural holdings. In a unit characterized by oversized items, at 21 feet 9 inches long, it stands out as one of the biggest.

Vital Statistics—Original Construction, 1914:

950 feet long

34,500 tons of rolled steel

2,000 tons of cast steel

2,000 tons of cast iron

6,500 tons of wood

3 million rivets

Gross tonnage: 54,282

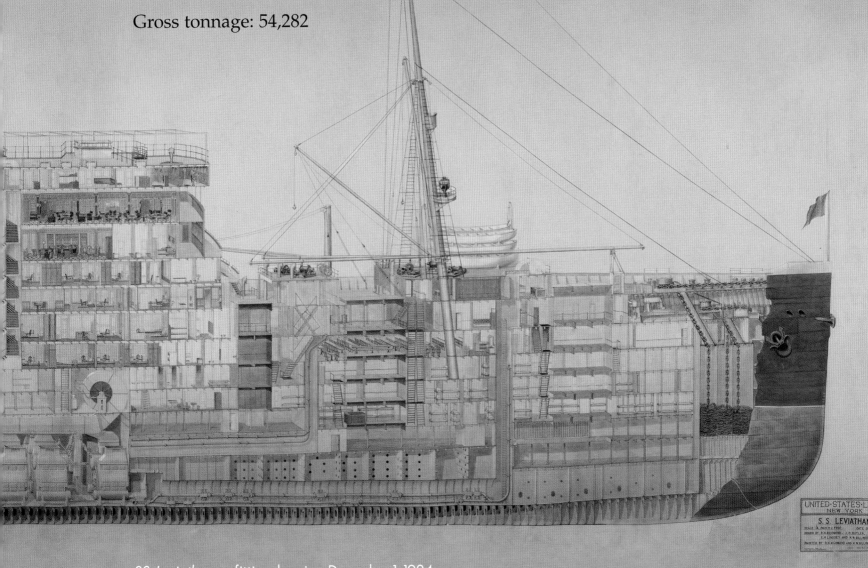

SS *Leviathan*, refitting drawing, December 1, 1924
National Archives, Records of the United States Shipping Board

83

Elephant House

The National Zoological Park was founded in 1889 and became part of the Smithsonian Institution in 1890. As its collections expanded in the 1930s, it began a new building program which used the services of artists working under the Federal Government's Public Works of Art Project, established during the Great Depression to provide jobs to unemployed artists. These drawings and other artwork created for the National Zoo were part of this program.

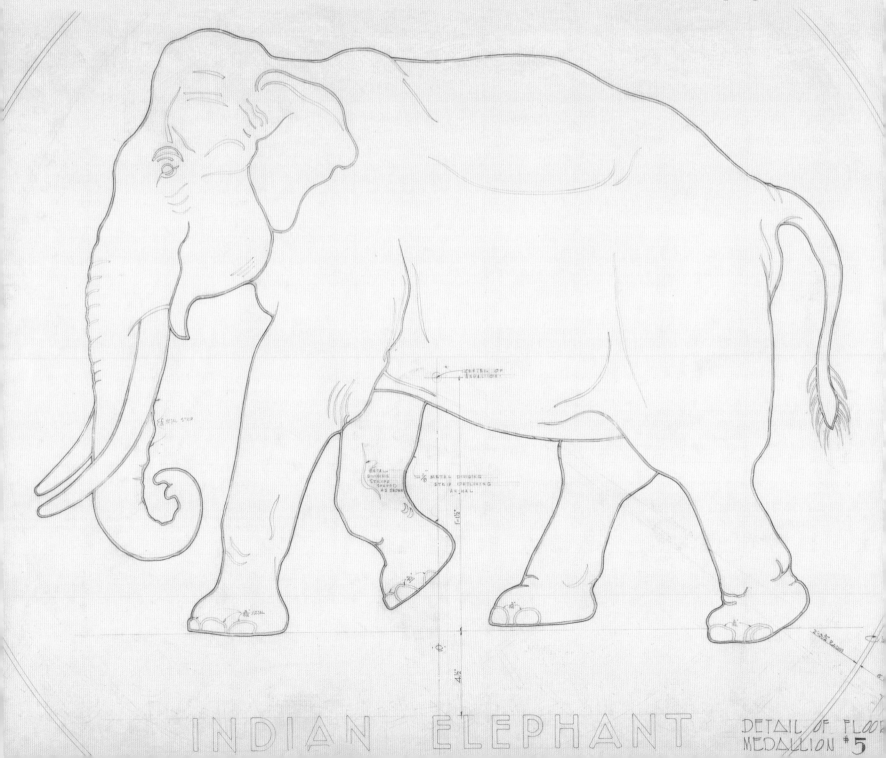

INDIAN ELEPHANT

DETAIL OF FLOOR
MEDALLION #5

at the National Zoo, Washington, DC

Background: Detail of drawing of elephants, designed by Charles R. Knight, for floor medallions inside the National Zoo's Elephant House, 1936

This design was executed as two of five terrazzo medallions built into the floor of the Elephant House. The African elephant (below), with the Indian elephant (opposite page), is the largest of all land mammals; the male of the species can weigh up to 12,000 pounds (6 tons).

National Archives, Records of the Public Buildings Service

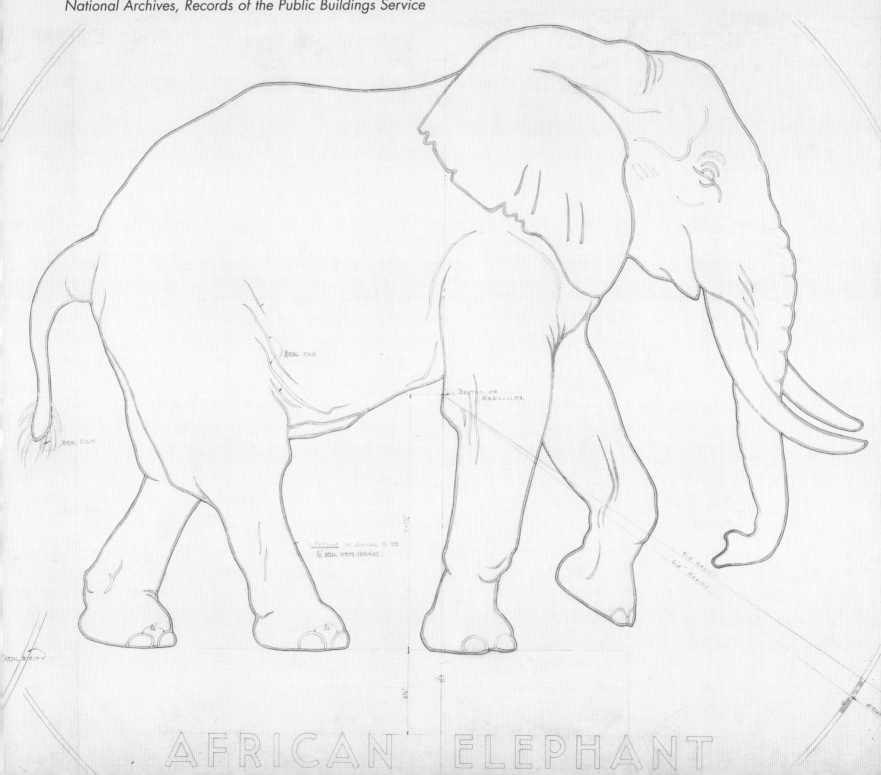

Dinosaur Track

This track, named *Eubrontes giganteus,* was made by a theropod (beast-footed) dinosaur. The *Eubrontes giganteus* would have stood approximately 9 feet high.

When the discovery of dinosaur tracks in an abandoned quarry in Roseland, New Jersey, made the local news in 1968, two teenage boys in a nearby town jumped on their bicycles and went to investigate. Working on their own, they uncovered thousands of fossilized dinosaur tracks, which experts later described as "something of a milestone in the history of these animals because of the large number of tracks." When the teenagers launched a successful campaign to preserve the site as an educational park, they earned an official commendation from President Richard Nixon.

One of those boys, Paul Olsen, is today one of the nation's foremost paleontologists, recently elected a member of the National Academy of Sciences. He recalls that he "went ballistic" when he learned about the discovery of the tracks near his home, and that the experience opened up a world of scientists and scientific resources that determined the course of his career. Although the plaque imbedded in the cast dates the footprint from the Triassic period (248 to 206 million years ago), Dr. Olsen recently stated that it is now thought to be from the early Jurassic period (206 to 144 million years ago).

Since the footprint itself has been lost, this cast remains the only non-photographic record of this particular track. It was made by Paul Olsen in 1970.

86

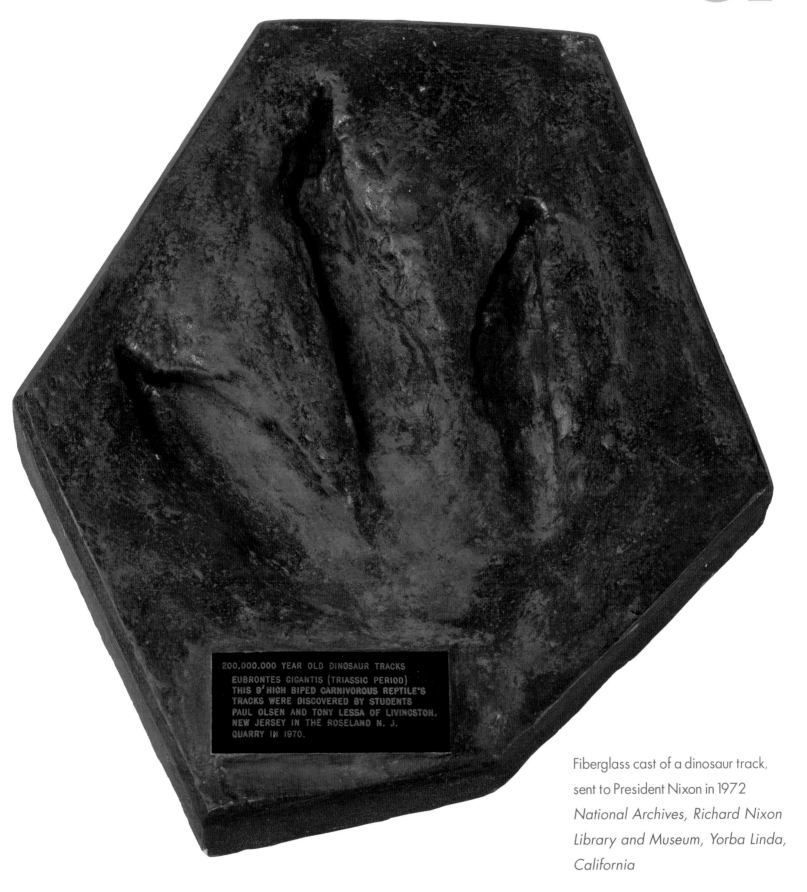

200,000,000 YEAR OLD DINOSAUR TRACKS
EUBRONTES GIGANTIS (TRIASSIC PERIOD)
THIS 9' HIGH BIPED CARNIVOROUS REPTILE'S
TRACKS WERE DISCOVERED BY STUDENTS
PAUL OLSEN AND TONY LESSA OF LIVINGSTON,
NEW JERSEY IN THE ROSELAND N. J.
QUARRY IN 1970.

*Fiberglass cast of a dinosaur track,
sent to President Nixon in 1972
National Archives, Richard Nixon
Library and Museum, Yorba Linda,
California*

AMERICA'S BIGGEST IDEA

" We hold these truths to be self-evident, that all men are created equal, that they are endowed by their Creator with certain unalienable rights, that among these are Life, Liberty, and the Pursuit of Happiness."

From the Declaration of Independence, July 4, 1776

The history of the United States is built upon a set of ideas and ideals, expressed by a group of British colonists scattered along the Atlantic seaboard during the last quarter of the 18th century. In justifying revolution, the Declaration of Independence asserted an eternal and universal truth about human rights in words that have inspired downtrodden people through the ages and around the world to rise up against their oppressors.

Shown on the opposite page is one of the copies produced by John Dunlap, the official printer of the Continental Congress. It was inserted into the "rough journal" of the Continental Congress within the July 4 entry.

The handwritten version of the Declaration, later signed by members of the Continental Congress, is on permanent display in the National Archives Building in Washington, DC, in the Rotunda for the Charters of Freedom.

Right: First printing of the Declaration of Independence, produced during the night of July 4–5, 1776
National Archives, Records of the Continental and Confederation Congresses and the Constitutional Convention

IN CONGRESS, JULY 4, 1776.

A DECLARATION

BY THE REPRESENTATIVES OF THE

UNITED STATES OF AMERICA,

IN GENERAL CONGRESS ASSEMBLED.

WHEN in the Courfe of human Events, it becomes neceffary for one People to diffolve the Political Bands which have connected them with another, and to affume among the Powers of the Earth, the feparate and equal Station to which the Laws of Nature and of Nature's God entitle them, a decent Refpect to the Opinions of Mankind requires that they fhould declare the caufes which impel them to the Separation.

We hold thefe Truths to be felf-evident, that all Men are created equal, that they are endowed by their Creator with certain unalienable Rights, that among thefe are Life, Liberty, and the Purfuit of Happinefs——That to fecure thefe Rights, Governments are inftituted among Men, deriving their juft Powers from the Confent of the Governed, that whenever any Form of Government becomes deftructive of thefe Ends, it is the Right of the People to alter or to abolifh it, and to inftitute new Government, laying its Foundation on fuch Principles, and organizing its Powers in fuch Form, as to them fhall feem moft likely to effect their Safety and Happinefs. Prudence, indeed, will dictate that Governments long eftablifhed fhould not be changed for light and tranfient Caufes; and accordingly all Experience hath fhewn, that Mankind are more difpofed to fuffer, while Evils are fufferable, than to right themfelves by abolifhing the Forms to which they are accuftomed. But when a long Train of Abufes and Ufurpations, purfuing invariably the fame Object, evinces a Defign to reduce them under abfolute Defpotifm, it is their Right, it is their Duty, to throw off fuch Government, and to provide new Guards for their future Security. Such has been the patient Sufferance of thefe Colonies; and fuch is now the Neceffity which conftrains them to alter their former Syftems of Government. The Hiftory of the prefent King of Great-Britain is a Hiftory of repeated Injuries and Ufurpations, all having in direct Object the Eftablifhment of an abfolute Tyranny over thefe States. To prove this, let Facts be fubmitted to a candid World.

He has refufed his Affent to Laws, the moft wholefome and neceffary for the public Good.

He has forbidden his Governors to pafs Laws of immediate and preffing Importance, unlefs fufpended in their Operation till his Affent fhould be obtained; and when fo fufpended, he has utterly neglected to attend to them.

He has refufed to pafs other Laws for the Accommodation of large Diftricts of People, unlefs thofe People would relinquifh the Right of Reprefentation in the Legiflature, a Right ineftimable to them, and formidable to Tyrants only.

He has called together Legiflative Bodies at Places unufual, uncomfortable, and diftant from the Depofitory of their public Records, for the fole Purpofe of fatiguing them into Compliance with his Meafures.

He has diffolved Reprefentative Houfes repeatedly, for oppofing with manly Firmnefs his Invafions on the Rights of the People.

He has refufed for a long Time, after fuch Diffolutions, to caufe others to be elected; whereby the Legiflative Powers, incapable of Annihilation, have returned to the People at large for their exercife; the State remaining in the mean time expofed to all the Dangers of Invafion from without, and Convulfions within.

He has endeavoured to prevent the Population of thefe States; for that Purpofe obftructing the Laws for Naturalization of Foreigners; refufing to pafs others to encourage their Migrations hither, and raifing the Conditions of new Appropriations of Lands.

He has obftructed the Adminiftration of Juftice, by refufing his Affent to Laws for eftablifhing Judiciary Powers.

He has made Judges dependent on his Will alone, for the Tenure of their Offices, and the Amount and Payment of their Salaries.

He has erected a Multitude of new Offices, and fent hither Swarms of Officers to harrafs our People, and eat out their Subftance.

He has kept among us, in Times of Peace, Standing Armies, without the confent of our Legiflatures.

He has affected to render the Military independent of and fuperior to the Civil Power.

He has combined with others to fubject us to a Jurifdiction foreign to our Conftitution, and unacknowledged by our Laws; giving his Affent to their Acts of pretended Legiflation:

For quartering large Bodies of Armed Troops among us:

For protecting them, by a mock Trial, from Punifhment for any Murders which they fhould commit on the Inhabitants of thefe States:

For cutting off our Trade with all Parts of the World:

For impofing Taxes on us without our Confent:

For depriving us, in many Cafes, of the Benefits of Trial by Jury:

For tranfporting us beyond Seas to be tried for pretended Offences:

For abolifhing the free Syftem of Englifh Laws in a neighbouring Province, eftablifhing therein an arbitrary Government, and enlarging its Boundaries, fo as to render it at once an Example and fit Inftrument for introducing the fame abfolute Rule into thefe Colonies:

For taking away our Charters, abolifhing our moft valuable Laws, and altering fundamentally the Forms of our Governments:

For fufpending our own Legiflatures, and declaring themfelves invefted with Power to legiflate for us in all Cafes whatfoever.

He has abdicated Government here, by declaring us out of his Protection and waging War againft us.

He has plundered our Seas, ravaged our Coafts, burnt our Towns, and deftroyed the Lives of our People.

He is, at this Time, tranfporting large Armies of foreign Mercenaries to compleat the Works of Death, Defolation, and Tyranny, already begun with circumftances of Cruelty and Perfidy, fcarcely paralleled in the moft barbarous Ages, and totally unworthy the Head of a civilized Nation.

He has conftrained our fellow Citizens taken Captive on the high Seas to bear Arms againft their Country, to become the Executioners of their Friends and Brethren, or to fall themfelves by their Hands.

He has excited domeftic Infurrections amongft us, and has endeavoured to bring on the Inhabitants of our Frontiers, the mercilefs Indian Savages, whofe known Rule of Warfare, is an undiftinguifhed Deftruction, of all Ages, Sexes and Conditions.

In every ftage of thefe Oppreffions we have Petitioned for Redrefs in the moft humble Terms: Our repeated Petitions have been anfwered only by repeated Injury. A Prince, whofe Character is thus marked by every act which may define a Tyrant, is unfit to be the Ruler of a free People.

Nor have we been wanting in Attentions to our Britifh Brethren. We have warned them from Time to Time of Attempts by their Legiflature to extend an unwarrantable Jurifdiction over us. We have reminded them of the Circumftances of our Emigration and Settlement here. We have appealed to their native Juftice and Magnanimity, and we have conjured them by the Ties of our common Kindred to difavow thefe Ufurpations, which, would inevitably interrupt our Connections and Correfpondence. They too have been deaf to the Voice of Juftice and of Confanguinity. We muft, therefore, acquiefce in the Neceffity, which denounces our Separation, and hold them, as we hold the reft of Mankind, Enemies in War, in Peace, Friends.

We, therefore, the Reprefentatives of the UNITED STATES OF AMERICA, in GENERAL CONGRESS, Affembled, appealing to the Supreme Judge of the World for the Rectitude of our Intentions, do, in the Name, and by Authority of the good People of thefe Colonies, folemnly Publifh and Declare, That thefe United Colonies are, and of Right ought to be, FREE AND INDEPENDENT STATES; that they are abfolved from all Allegiance to the Britifh Crown, and that all political Connection between them and the State of Great-Britain, is and ought to be totally diffolved; and that as FREE AND INDEPENDENT STATES, they have full Power to levy War, conclude Peace, contract Alliances, eftablifh Commerce, and to do all other Acts and Things which INDEPENDENT STATES may of right do. And for the fupport of this Declaration, with a firm Reliance on the Protection of divine Providence, we mutually pledge to each other our Lives, our Fortunes, and our facred Honor.

Signed by ORDER *and in* BEHALF *of the* CONGRESS,

JOHN HANCOCK, PRESIDENT.

ATTEST.

CHARLES THOMSON, SECRETARY.

PHILADELPHIA: PRINTED BY JOHN DUNLAP.

MONDAY	TUESDAY	WEDNESDAY	THURSDAY	FRIDAY	SATURDAY	SUNDAY

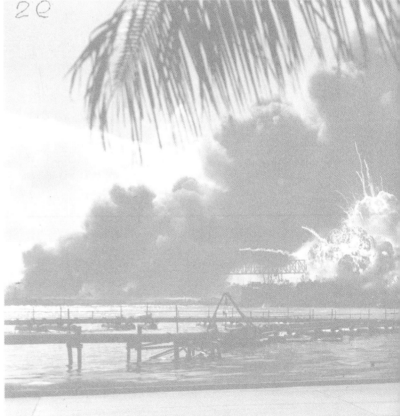